ILLUSTRATED TALES OF
GUERNSEY

SOO WELLFAIR

AMBERLEY

About the Author

Soo Wellfair was born in Berkshire, England. She first visited and fell in love with Guernsey in the year 2000. She quickly adopted the island as her second home and now lives on Guernsey with her husband and children, where she works as a gold accredited tour guide and freelance writer. As a tour guide, Soo specialises in walking tours which make the most of Guernsey's beautiful and varied terrain and has a special interest in the folklore social history of the island.

Dedicated with love to my husband and best friend, Rich

First published 2023

Amberley Publishing
The Hill, Stroud
Gloucestershire, GL5 4EP

www.amberley-books.com

British Library Cataloguing in Publication Data.
A catalogue record for this book is available from the British Library.

ISBN 978 1 3981 1393 0 (paperback)
ISBN 978 1 3981 1394 7 (ebook)

Origination by Amberley Publishing.
Printed in Great Britain.

Contents

Introduction

The Bailiwick of Guernsey is a cluster of small islands which includes Guernsey, Alderney, Sark and Herm. With a history going right back to prehistoric times, Guernsey and its neighbouring islands are rich in folklore, legends and customs. Small island communities in their very nature tend to have a distinct heritage based on storytelling and these tales are passed down from generation to generation. Tales of folklore almost always originate from the truth, even if they are altered so much over the centuries that they end up almost as fairy tales. Folklore is history. It is the history of the people. However, folklore is not just about stories and legends. It is also the foundation of what makes a community what it is. What makes a certain group of people or culture special? Their customs, their superstitions. The strange little quirks and ways of a bygone era that still form part of a place's identity. The things that local people may take for granted as 'the norm' but may seem absolutely fascinating or bewildering to a visitor. In this book, we will be exploring the folklore and legends of the Bailiwick of Guernsey, as well as some of the things that could be considered 'quintessentially Guernsey'.

The Devil in Guernsey

The Devil makes many appearances in Guernsey's tales of folklore and legends. Although the Devil as an entity is described in many different forms in the various texts that have referenced him throughout history, in Guernsey, the Devil is mostly portrayed as a cloven-hoofed, animal-like character. In this form he is often referred to as La Barbarie. Unsurprisingly, the Devil in Guernsey folklore is often associated with other characters linked with the occult and black magic such as witches.

The Devil's Hoofprint

Some of the very best tales of folklore are ones which relate to a place, a building or relic that we can go and visit for ourselves. To be able to see it, maybe even touch it, helps bring its story to life. The Devil's Hoofprint (also known as Le Pied du Boeuf) is a wonderful example of this. It's a place that people will continue to seek out for generation after generation.

The story behind it involves a legendary encounter between good and evil, where a local saint (quite possibly St Sampson) took on the Devil himself, in a bid to banish him from Guernsey.

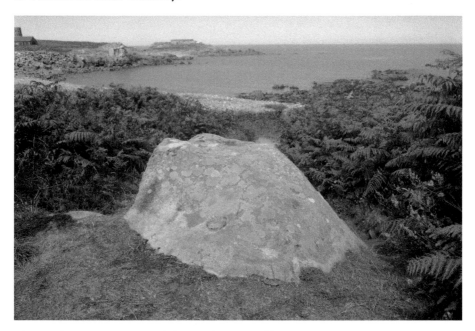

The Devil's Hoofprint/Le Pied du Boeuf. (Soo Wellfair)

An almighty battle took place, and the pair fought tirelessly as their conflict took them all around the island, from parish to parish. Eventually, the skirmish came to a dramatic conclusion at a spot near the northern coastline. It was at this point that the saint was victorious over the Devil, who in a fit of rage stamped his cloven hoof on a nearby rock before leaping into the air and away from Guernsey. Legend has it he headed north towards Alderney and although the Devil had departed Guernsey, he had left his mark quite literally. On the rock where he had stamped his hoof when defeated, he left an imprint. The rock and its imprint can still be found today, just off the coastal path between Fort Doyle and Fort Le Marchant.

The Priest's Chair

If you were to take a walk around the craggy, coastal path which leads around the very north of the island, you will find the Priest's Chair. In an area named Le Creve Coeur, there is a rock formation that, if you look carefully, you will spot what appears to be a large chair carved out of the granite. Legend has it, another epic battle between the Devil and a local member of the clergy took place at this very spot. After a long and tiring confrontation with the Devil, the priest who had valiantly taken him on fell back exhausted after winning the fight. As he fell, the rocks around him formed a stone chair, allowing the weary clergyman to rest and recuperate.

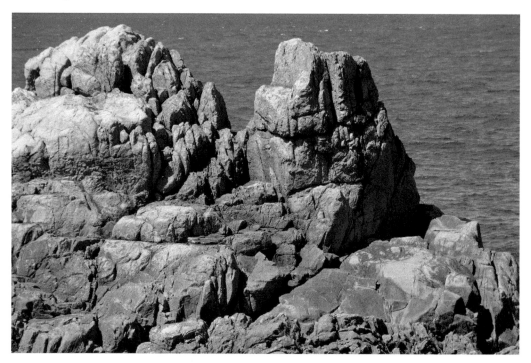

The Priest's Chair. (Soo Wellfair)

Le Catioroc

The headland known as Le Catioroc is a very interesting site with much history. The area became notorious in the sixteenth and seventeenth centuries as the island's main meeting point for the Devil and his loyal followers. Legend has it a coven of witches would meet during the sabbat and dance on top of the nearby passage grave, known as Le Trépied. This prehistoric tomb was built during the Neolithic period (4000–2500 BC) and evidence shows it was still in use during the late Bronze Age (1000 BC). It is said that occasionally the witches were forced to move their meeting further along the coast to Rocquaine, as the forces coming from nearby monks at the Lihou Priory occasionally interfered with their spell-making.

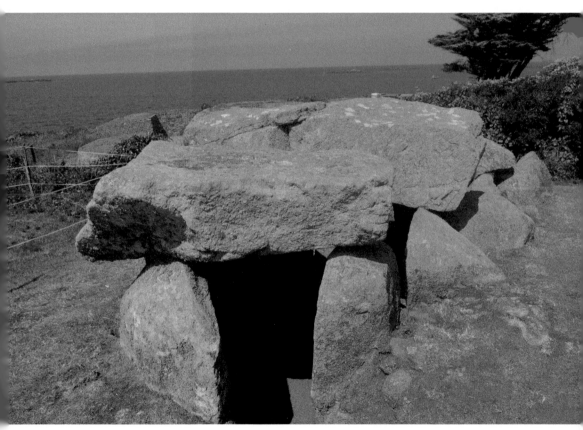

Le Trépied Passage Grave, Le Catioroc. (Soo Wellfair)

Black Magic

Guernsey Witches

There would have been a time in Guernsey when many people would have truly believed that witchcraft was being practised on the island. It is likely that part of this was down to the number of islanders, particularly in rural areas, who were accomplished herbalists. Using local herbs, plants and flowers to create medicines and remedies was once a perfectly normal and acceptable part of pastoral life. The Pellitory-of-the-Wall for example, was known for its antiseptic qualities and used both topically on wounds and burns and internally for kidney and stomach complaints. The Pennywort (also known as the Navelwort) is still a popular remedy for nettle stings. Somewhere along the line though, certain individuals and families started to get a reputation for dabbling in a bit more than cough tinctures, digestive aids and lotions for cuts and scrapes. Whilst many of these traditional customs were still commonplace in the more rural parishes, it is likely that the island's 'Townies' had moved away from this way of life and had started to regard these practices as forms of magic. Gossip and rumours were rife and it didn't take much for an individual to be tarnished with the name 'Witch' and there are many tales of supernatural incidents involving potions, charms and curses. One such incantation is 'Butyrum de Armento', an unusual curse that would be aimed not at humans, but at cattle. The curse would render a cow

The medicinal Pennywort and Pellitory-of-the-Wall plants. (Soo Wellfair)

unable to produce milk. The poor creature would instead only be able to produce blood from her udders! Whilst in twenty-first-century Guernsey, witchcraft is not widely believed in, there are still certain local surnames that are very much associated with having a family history of sorcery.

Witchcraft was categorised into two main types: white magic and black magic. White magic involved spells and potions intended to be used to help others, whereas those practising black magic were far more likely to inflict curses on their enemies and make attempts to summon demons. Both, however, were decidedly frowned upon, particularly after witchcraft of all kinds was declared heresy and forbidden by the Catholic Church in the late fifteenth century.

As well as Le Catioroc, there are several key locations around the island that are steeped in history and folklore relating to witches and witchcraft. One of these areas is Tower Hill, which is infamously known as the main site used to execute local witches. It is also near the site of the former Tour de Beauregard, an old fort once used to hold the condemned, prior to execution. Between the mid-sixteenth and mid-seventeenth centuries it is believed that around 100 people in Guernsey were put on trial for witchcraft. Guernsey was a very superstitious island in those times as well as being caught up in a great deal of religious unrest and change. Trials were not particularly fair and quite often some frankly dubious forms of evidence were used during the process. A good example of this would be the consultation of a person known as a Witch Pricker. Always a man, the Witch Pricker, as the name would suggest, would use a sharp needle to prick the skin of the accused. It was claimed that witches bore the mark of the Devil, and if pricked with a needle in this part of the body, will neither bleed nor feel pain. There is evidence to suggest that the Witch Picker's needle may have actually been a two-ended instrument. One end would have been sharp, which was used to first draw blood from a part of the body of the accused that bore no markings. This would be done to prove to the audience that the needle was capable of penetrating the skin. It would then be secretly inverted and a blunt end would be used against the accused's so-called mark of the Devil. It would of course cause no real harm, thus backing up the claim that the accused was, in fact, a witch. The most famous case is that of Catherine Cauches and her two daughters Guillemine Gilbert and Perotine Massey, now known as the Guernsey Martyrs. Found guilty of heresy in 1556 because of their protestant beliefs, the three women were burnt at the stake on this site. As you will see for yourselves if you read the memorial plaque halfway down the steps, there is a rather unpleasant twist to this tale. Perotine Massey was heavily pregnant at the time of execution and gave birth to a child after her labour was induced by the shock of the fire. The child was retrieved and thrown back into the flames by order of the Bailiff.

Just like Catherine Cauches and her daughters, many of the men and women accused of witchcraft were targeted due to their religious leanings, often influenced by the English monarch of the time. Queen Mary, in a bid to overturn her father Henry VIII's Reformation, was responsible for the deaths of countless

Tower Hill, site of the Guernsey Witch Trials. (Soo Wellfair)

Protestants, earning her the nickname 'Bloody Mary', and even a small island such as Guernsey was not immune to her powerful influence.

There is a fascinating story which is actually very modern compared to many stories revolving around witches, spells and potions. In some places, witchcraft was still a matter of concern for some people, well into the early twentieth century. In fact, the last witchcraft trial was held in Guernsey in 1914. A local woman, Mrs Aimee Lake, was well known locally for being something of a fortune teller and also for selling natural remedies and charms. She was accused by a local farmer's wife named Mrs Houtin who, after the death of her husband and loss of her herd of cows, visited Mrs Lake as she hoped she would help cure her spell of bad luck. Mrs Lake presented the widow with a packet of so-called enchanted powders, with instructions to throw a small amount towards her enemies and to bury the rest. This would, she claimed, relieve her of the curse she had been put under. Mrs Houtin reported Mrs Lake to the police after receiving threats from her. She alleged that she had paid Mrs Lake for her services on two occasions but Mrs Lake had then asked for even more money, threatening to re-curse Mrs Houtin if she did not oblige. It turned out that this was not the first time Mrs Lake had used the threat of witchcraft to extort money from superstitious islanders. The enchanted potions were used as evidence to prove her witchery but when the substances were fully examined and tested, it was revealed that they were merely a mixture of everyday baking ingredients, mostly corn flour. However, she was still found guilty of witchcraft but luckily for her the punishment has lessened somewhat over the centuries. In fact she served just eight days in prison, which, at the time, was the maximum penalty allowed for that particular crime.

Witches' Seats

Some of Guernsey's older cottages were designed with quite a quirky addition to their architecture. A stone plinth, jutting out from the gable end, usually just under the chimney stack, is known in Guernsey as a witches' seat. Originally built to prevent rainwater seeping through thatched roofs, these funny little platforms soon became ingrained in local legend. These stone seats were believed to be used as a way to deter witches from entering the homes of fearful islanders. Some believe that Guernsey witches did not actually ride on broomsticks, but had instead, a small set of wings, which is why they grew tired mid-flight and would look for a seat on which to rest. If, however, no such seat could be found, the weary witch may instead decide to enter a household via the chimney and, quite often, choose to take up residence there. It therefore became quite popular for witches' seats to be added to houses and even included in the design of newer houses, long after thatched roofs were being used. The most famous witches' seat in Guernsey is the one at a local inn named The Longfrie. A resident witch has been in situ on the side of the building for at least sixty-five years. Although she has been replaced several times during this period, this spooky effigy has been popular with local children and visitors for generations. Her latest makeover,

The Longfrie Inn Witch. (Soo Wellfair)

given in 2015, made front page news and even inspired a song titled 'The Witch of The Longfrie' by local band The Space Pirates of Rocquaine.

It may surprise you, given the popularity of the Longfrie Witch and her reputation as something of a local landmark, that she does not actually sit on a witches' seat anymore! The original seat was removed sometime in the 1970s during maintenance on the building and she is now secured to the building by some other means – perhaps magic!

Spell Books

The notion of casting spells is quite an old one, with evidence suggesting a number of historical civilisations including the Greeks, Romans, Egyptians and even ancient Mesopotamians used spell books in some form. In the eighteenth and nineteenth centuries the concept of practising magic became much more accessible with the rise in popularity of grimoires. Grimoires were essentially textbooks of magic, aimed at the general household. Two of the most well known of the books were named *Le Petit Albert* and *Le Grand Albert*. These books were both highly revered but equally feared! It was believed that not only did they contain powerful spells, but the actual books themselves contained some sort of supernatural power. Those of a superstitious nature believed that simply touching these books could be deadly and even today, some people will refuse to do so. It is also thought that these publications are completely indestructible.

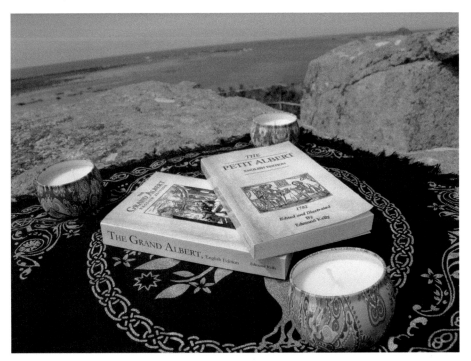

The Black Books. (Soo Wellfair)

The '*Alberts*' were most popular in France, with most households owning a copy, and it is probable that quite a few copies made their way over to Guernsey. They are certainly referenced in publications of around that time and there are copies held in the strongroom of the Priaulx Library and on display in the Guernsey Museum at Candie. It is also likely that there are a few copies hidden away in attics. They are often referred to simply as the Black Books.

The Prior of Lihou

One of the local legends involving the Black Books involves a prior with some pretty serious leanings towards black magic. Based at the priory on Lihou island, he was in possession of the Black Books, and his interest in the occult was known to his superiors within the church. He had been warned on many occasions to cease his dabblings with sorcery but he chose to ignore them. The prior had an acquaintance based in St Saviour who had a similar interest in the black arts and they would regularly meet up to read the grimoires together. After one of these meetings the prior and his servant boy prepared to make the journey back to Lihou, walking across the causeway at low tide. The prior had given his copy of Le Petit Albert to the boy to carry. As it was rather heavy he was unable to keep up with his master, who was striding towards Lihou with some haste as he was conscious of the ever rising tide. It wasn't until the prior had reached the halfway point when he turned to see the boy was sitting on a rock at the very start of the causeway. Although the prior had warned the boy not to open the book, he could see that he was engrossed in reading it. The prior called across to the boy, who appeared not to hear him. What he could not see from that distance was that the servant was not only reading from *Le Petit Albert*, but reading aloud, unknowingly casting a spell as he spoke! He did, however, notice the tide start

The Lihou causeway at high tide. (Soo Wellfair)

The Lihou causeway at low tide. (Soo Wellfair)

to suddenly rise, much faster than usual. He realised too late that the boy had unleashed a spell that was bidding the sea to rise. Before he had time to react, the causeway had been completely submerged in sea water and the prior was drowned. Shortly after, the boy stopped reading, the tide returned to normal and the causeway was revealed once more. The prior however, had been swept out to sea and was never seen again.

The Old Witch of Cobo

Another local story featuring the legendary Black Books is the tale of an old woman in Cobo. The woman, who appeared to have no friends or relatives, chose to live a solitary and mysterious life and had gained a reputation of being a witch. Although she lived in quite a remote area, there were a number of neighbouring cottages and farms close to her dwelling. Over time, however, several of her neighbours had moved out and the buildings had remained empty year after year. Rumour had it the woman, who had been nicknamed 'The Old Witch of Cobo', had been undertaking something of a personal vendetta against her neighbours, using spells and curses to force them all out, one by one. Eventually, one of these vacant properties was rented out to an Englishman who had come to Guernsey for work. He had been surprised to find so many empty houses in such a beautiful location and when he managed to find the landlord of one of the cottages, he found him reluctant to rent it out. When he eventually secured a tenancy and had moved in with his family, he started to feel like the house was either haunted or cursed. Objects would fly through the air, heavy furniture would come crashing

down right beside him, strange noises could be heard at all times of the day and night and his pet dog started to behave quite strangely. It wasn't long before the man sought advice and he was told many stories of how the woman had bewitched her neighbours, and how she had managed to force each one out of their homes, simply because she resented them being there. He was also told that the woman owned copies of *Le Grand Albert* and *Le Petit Albert* and that these were the source of all her powers. Many had tried without luck to destroy them, and it was strongly believed that these seemingly indestructible books could only have their power removed after the death of the owner, and should be buried with them. The man started to think he would have to move out and started to make arrangements to do so, when he heard of a new resident in the area. He was told that this newcomer was actually a white warlock and the man begged him for his help. The warlock could not do anything about the books but he was able to block the witch's curses and spells. Legend has it she was so frustrated at being thwarted and so exhausted from trying to cast spells unsuccessfully, that she died. She was buried with her magic grimoires and all was peaceful in Cobo once more.

Cobo, an old witch's haunt. (Soo Wellfair)

3

Fairies and Pouques

Guernsey legends are full of stories involving fairies and their antics. Fairies come in all shapes and sizes, some are good and benevolent, some are mischievous or sometimes vengeful. Some fairies are meek, mild and shy, whilst others are powerful and confrontational. In Guernsey there are thought to be two main types of fairy. Firstly, the mysterious exotic fairies believed to come from a faraway fairyland that visit the island through a series of magical gateways or fairy doors (often located in caves around the coast). The second type are known as Pouques and are an indigenous variety of fairy, known specifically in the Bailiwick, with some variations across the islands (the Sark Pouques, for example, have removable heads!). Pouques are thought to be much larger that non-native fairies and live in dwellings known as Pouquelie. These are often in areas associated with ancient traditions and magic, such as prehistoric menhirs and passage graves, such as Le Creux ès Faies (The Fairy Cave). Quite often these are in the same areas where the gateways to Fairyland are located, although it is unclear if any Pouques have ever left their island home to visit this mystical land. Pouques are considered to be less dainty and graceful as their overseas counterparts and are much more 'gnome-like' in appearance and there are many

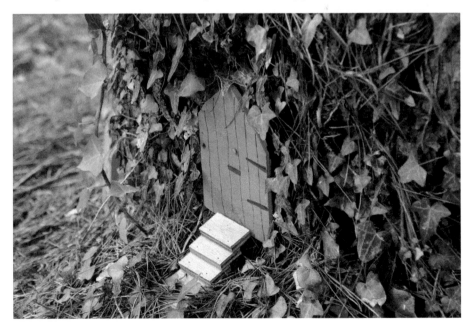

A Guernsey fairy door. (Soo Wellfair)

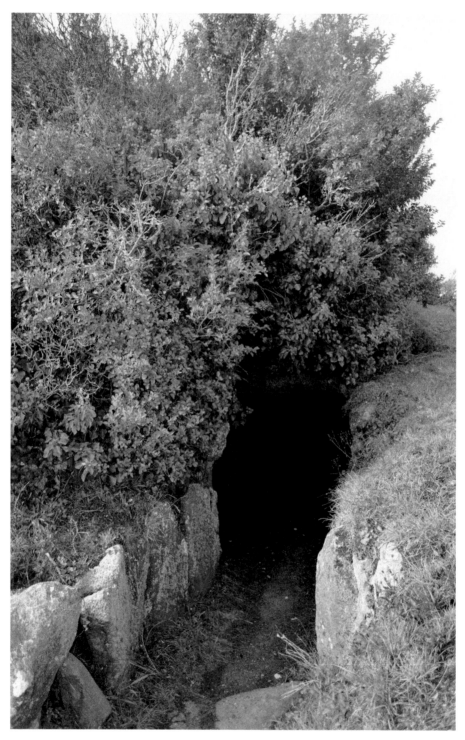

Le Creux ès Faies passage grave. (Soo Wellfair)

The Guernsey Lily. (Soo Wellfair)

stories involving Pouques interacting with mortals. Both types of fairies are thought to enjoy dancing around the famous Fairy Ring near Portelet, and if you walk or dance around the Fairy Ring you may be granted a wish. The Fairy Ring is a circle of stones which surrounds an old natural table, carved out of the ground. It is officially named La Table des Pions. The table was used during an island-wide procession known as the Chevauchée, which was an elaborate inspection of Guernsey's roads and pathways, which took place in anticipation of the arrival of visiting dignitaries. Lunch would be taken at the nearby Fort Pezeries with the pions (the footmen) seated at the carved, earth table.

The Fairy Invasion and the Guernsey Lily

One day a beautiful young farm girl named Michelle de Garis was taking a walk along her favourite beach, Vazon. She spotted a figure curled up asleep at the top of the bay and as she approached him, he awoke. Michelle found herself face to face with the king of the fairies. They looked at one another and instantly fell in love! The Fairy King begged Michelle to go back to fairyland with him and become his Fairy Queen. She was tempted but had concerns about her family and didn't wish to cause them any worry or upset. The Fairy King told her not to worry; there was something he could do to help. With this, he produced a tiny flower bulb from his pocket. This tiny but magical little bulb turned out to be the first ever Guernsey Lily, also known as the Nerine Sarniensis. The Fairy King

carefully planted it in the sand and off they went in his boat, back to Fairyland. Later that day, after Michelle had not returned home at the usual time, her mother went searching for her. Michelle always wore a distinctive bright red cloak and as her mother reached Vazon and scanned the bay, she saw a flash of red and ran towards it thinking it was Michelle. What she found was, in fact, the now fully bloomed lily that had been planted. Mrs De Garis was instantly comforted by its magical powers and knew in her heart that her daughter was happy and safe. Meanwhile, back in Fairyland the other male fairies were absolutely enchanted with Michelle and decided that they wanted Guernsey brides for themselves. Without any delay, an army of fairies took to their sailboats and stormed the beaches of Vazon. This was something of a hostile invasion and a bloody battle took place between the fairies and the islanders, who were understandably unwilling to let the island's young women be whisked off by a battalion of fairies! Eventually the fairy army were victorious and slayed all local men apart from two who had hidden inside an oven. They took their brides and rather than return to Fairyland with them, settled in Guernsey and raised children. However, after some time, Fairyland law meant they had to return and they left behind an island of halflings! It is believed that Guernsey folk today still have fairy blood! Short, dark haired Guerns are said to descend from the fairies and taller, fairer Guerns from the two surviving men who hid during the battle. There are many different variations of this story and some believe the origin of the story of the fairy invasion was actually a very similar tale relating to the invasion of Owen of Wales in 1372. Owen, the heir to the last native Prince of Wales, had been made leader of a French army, which had been put together to challenge the English monarchy. In both cases, an army attacked Guernsey, landing at Vazon Bay, and instigated a series of lengthy and bloody battles. Both stories have been linked to a St Peter Port road named Rouge Rue (Red Road) as it is believed the road was named after so much blood was shed there that it literally ran down the road like a river of red.

The Pouques and the Broken Kettle

One day, two men were hard at work, ploughing a field at L'Eree on the west coast of Guernsey. Suddenly their plough stopped, as did the oxen pulling it and no matter what they tried to do, the plough would not move an inch. One of them spotted an object nestled in the soil they had just ploughed and picked it up to inspect it. It was an old iron cooking kettle, which appeared to be broken. Just as the man was about to discard it, both men heard a tiny but clear voice asking him to fix the broken kettle and replace it. As the men were unable to complete their work on the field anyway, they took the kettle to a nearby forge, repaired it and took it back to the field, setting it down exactly where they had found it. They were pleased to find their plough was working again and they resumed their work. After they had completed several furrows and had returned to the spot where they had discovered the broken kettle, the plough suddenly stopped

again. This time, in the place where they had left the kettle after repairing it, they found a mysterious bundle and a wonderful surprise. Inside the bundle was a freshly baked cake and a bottle of cider, and they once again heard the same voice as before, which thanked them for their help and invited them to enjoy their reward.

There are many stories of how the Pouques rewarded mortals with gifts for helping them in their daily tasks. However, it is safe to say the Pouques were fairly selective in whom they chose to assist, and did not seem to appreciate being taken for granted. They also tended to help only those who had either helped them first without expectation of reward, or those who were truly needy. The Pouques would not help anyone they considered to be work-shy. In fact, if they ever felt coerced into anything, they may feel tempted to punish the mortal instead. In general, the Pouques liked to be the ones to instigate any 'deal'.

The Pouques and the Baker's Wife

A baker's wife was up late one night knitting, after her husband had gone to bed. She was quite alone when she heard an unexpected knock at the door and she heard a friendly voice ask if her oven was still warm enough for baking. Before she had time to get out of her chair and open the door, the door opened a few inches by itself then gently closed again. As she sat, bewildered in her chair, she could hear tiny footsteps scurrying around her kitchen, small, hushed voices in conversation, the sound of pots

The Fairy Ring/La Table des Pions. (Soo Wellfair)

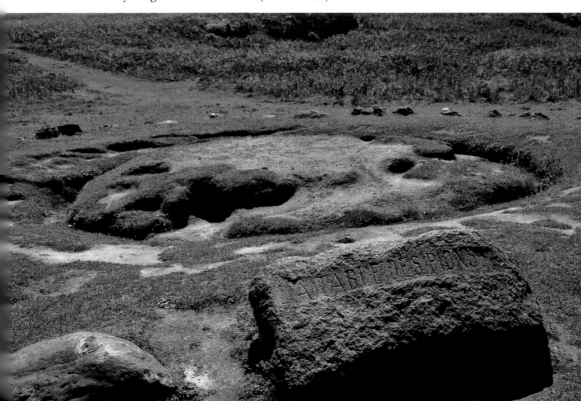

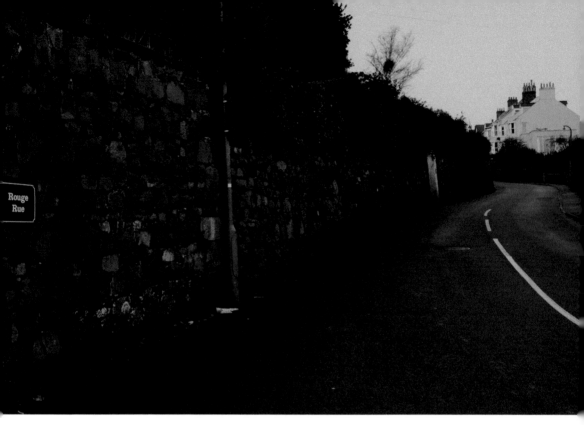

Rouge Rue, St Peter Port. (Soo Wellfair)

and pans being bashed and the door to her oven being opened and closed. Her little kitchen was a hive of activity, yet she couldn't see anyone there. She remained seated until, once again, the cottage door opened and closed. As soon as she was quite certain it was just her in the room, she stood up and slowly made her way around the kitchen, searching for whoever or whatever had just been there, but she found nothing. When she reached her kitchen table, however, she found a loaf of freshly baked bread, left for her as a gift of thanks for allowing the Pouques to use her oven.

The Pouques' Cricket Match

In a field in an area called Les Paysans stands a mighty menhir or standing stone named La Longue Rocque. Legend has it the stone is actually a giant cricket bat, once used by two of Guernsey's Pouques, Lé P'tit Colin and Lé Grànd Colin. One day, these two Pouques were playing a rather oversized game of cricket, using the menhir as a bat and a boulder as a ball. When Lé P'tit Colin bowled the boulder towards his friend, Lé Grànd Colin struck it with such force that it soared through the air, miles away from where they were playing, and ended up embedding itself in the hillside not far from Portelet harbour. An argument between the Colins broke out and Lé Grànd Colin lost his temper and rammed his bat into the ground, where it still stands today. The Pouques were not well known for their sportsmanship.

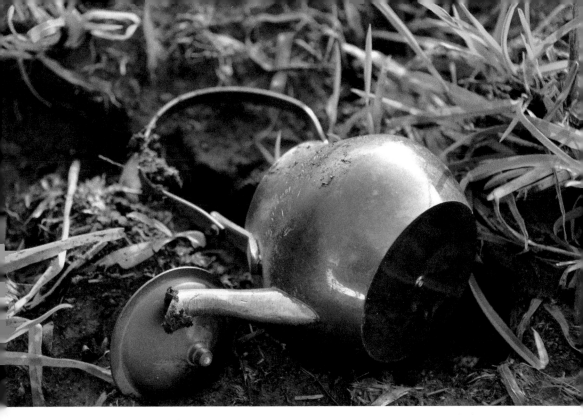

Above: The Broken Kettle. (Soo Wellfair)

Right: La Longue Rock/a giant cricket bat. (Soo Wellfair)

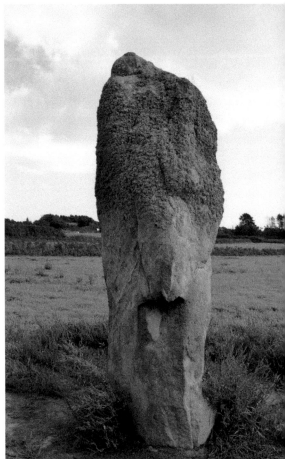

4

Demonic and Enchanted Creatures

Guernsey folklore is awash with stories of demonic and enchanted creatures!

Just across the road from Vale Church is a road named Ville Baudu. Some believe it is named after a mythical creature Bôdu, the demon dog. Going by a variety of different names including Tchîco, La Bête and Tehteo, these terrifying hounds famously haunt a number of different locations across Guernsey. The resident beast of Ville Baudu is said to roam an area that was once the site of an old slaughterhouse associated with the original priory and was an area viewed with great superstition and fear. It is considered terribly bad luck to encounter any of these hideous creatures with their blazing red eyes and jaws full of enormous fangs. Often only identified by the sound of howling or of heavy chains being dragged behind it, the demon dog, if witnessed, was said to be a prophecy of death.

Another of these is La Bête De La Tour, who prowls around Cornet Street and Fountain Street, near the site of the former Tour de Beauregard, where the condemned were once held before being executed at Tower Hill.

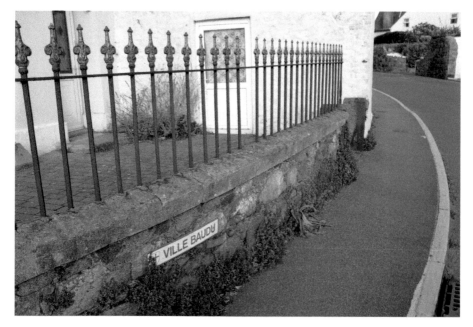

Ville Baudu, home of Bôdu, the demon dog. (Soo Wellfair)

Demon dog. (Joshua Slate)

The former Tour de Beauregard, where the La Bête De La Tour prowls. (Soo Wellfair)

There are two areas in Guernsey both named Les Varioufs: one in St Martin and one in The Forest. Les Varioufs means werewolves (a human that transforms into a wolf during a full moon). So were there real werewolves in this area? There are two possible explanations as to why these areas are named Les Varioufs. Firstly they are regions in the south of Guernsey, near the cliffs where a lot of smuggling and other crimes may have taken place in the dead of night. In a bid to keep people away from the south cliffs, rumours were spread that werewolves prowled the area and those regions became associated with Les Varioufs and eventually called that.

The other theory is that Les Varioufs used to be how people referred to the young men of the island who went out drinking at the weekend and would roam the streets after the inns had closed, brawling and howling and being generally disruptive.

La Biche is a phantom nanny goat that haunts an area named Le Coin de la Biche, the goat's corner. This giant goat was known to stop passing farmers in their tracks by jumping up and resting her front legs on the back of their carts. La Biche was so big and heavy the oxen pulling the cart would not be able to

White horses are believed to be magical. (Soo Wellfair)

move it. One story tells of one farmer having to unharness his oxen and make a speedy getaway from the furious looking beast and return for the cart and its contents the following morning. Another story is a bit more serious. A former churchwarden who lived in the same area as a boy recalled how after claiming to have seen La Biche, his sixteen-year-old sister suddenly became ill and died.

Ghostly horses are fairly common in Guernsey. A phantom horse with fiery eyes and flaring nostrils is said to appear near the holy well of St George in the Castel, at Les Piques in St Saviour and Colborne Road in St Peter Port. White horses in general are thought to be enchanted and magical creatures.

There are a few beliefs and superstitions regarding pigs in Guernsey. Some believe that pigs should never be slaughtered during a waning moon (when it moves from full to new) as the meat will not be good. Guernsey matrons in Victorian times used to rub the scalp of patients with an ointment made of pig rind. It was said that a lady who died at seventy-eight still had golden blonde hair because she used this ointment regularly. Pigs that feature in supernatural stories are almost always female. A good example would be the sow that haunts Vazon beach with her litter of piglets, where an ancient forest used to be. It is thought that the forest in question was wiped out by a huge tidal wave around 10,000 years ago. At times when the weather has been especially stormy and sand levels on the west coast drop significantly, the petrified remains of the forest are exposed.

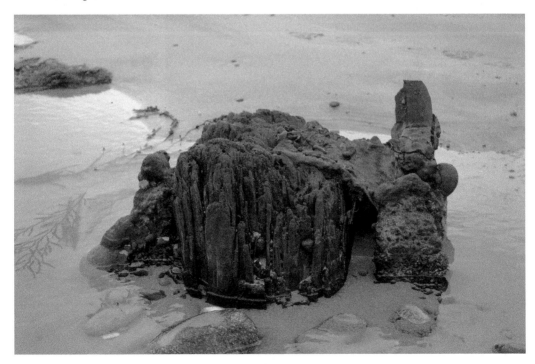

The petrified forest at Vazon. (Soo Wellfair)

Guernsey Superstitions

Small islands such as Guernsey are often thought to have residents with slightly more superstitious tendencies than their mainland counterparts. Whether this is accurate or not is debatable, although it is certainly true that Guernsey has an interesting collection of old local superstitions and cultural beliefs. Many of Guernsey's superstitions would have, of course, been adopted from other places and cultures, as are many of the superstitious beliefs from around the world. Many of these are very well known amongst most of us and some can be dated back to ancient times or would have been centred around religious beliefs. A superstition is when a group or individual feels that a certain action can result in either good or bad luck with no real logical explanation, and is therefore often linked with magic. Good examples of these would be not opening an umbrella indoors, walking under a ladder or putting new shoes upon the table. These are all quite irrational things to believe in, yet many are ingrained in us since childhood and are merely habitual. Guernsey has an interesting collection of strange and unusual superstitious beliefs including the following.

Items made of iron, such as horseshoes, should be either hung from the front door or placed in the attic to help ward off evil spirits. Horseshoes were particularly effective as witches were believed to be afraid of horses and anything associated with them.

Any chest or throat ailments can be cured by consuming a large quantity of raw colimâchaon (Guernsey snails) or wrapping a sock, heavy with the owner's sweat around the neck.

A spider web should be applied to bruises or cuts to speed up the healing process.

Wearing an item of clothing inside-out on purpose is considered bad luck, although it is actually good luck if the task was performed unintentionally.

If you eat a boiled egg you should destroy the shell afterwards, otherwise small devils or witches can use the empty eggshell as a boat and cause terrible storms at sea.

If an unmarried woman places a slice of cake from a wedding under her pillow, she will dream of her future husband.

You should never do your washing on New Year's Day as it washes away your good luck for the year ahead.

If you come across a single magpie you must greet him with the phrase 'Good day Mr Magpie, how is your lady wife today?' or words to that effect. In the UK, it is more common to greet the Magpie as 'Captain'.

It is extremely good luck to have a rosemary bush in your garden but only if it was given to you as a gift.

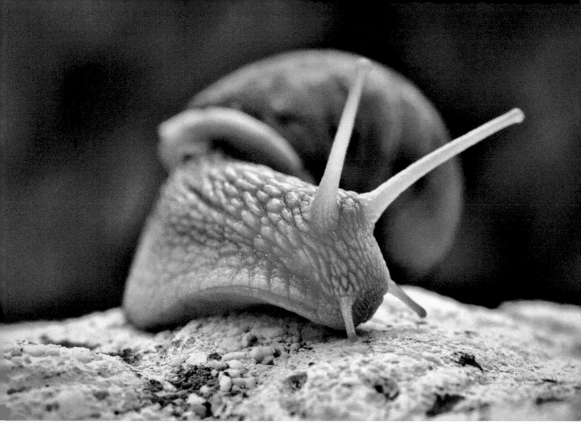

Above: The colimâchaon (snail), once a home remedy for chest complaints. (Ralphs_Fotos)

Below: Horseshoes are hung on doors to ward off evil spirits. (Soo Wellfair)

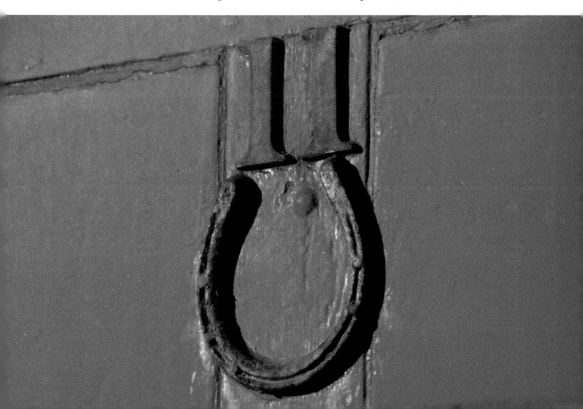

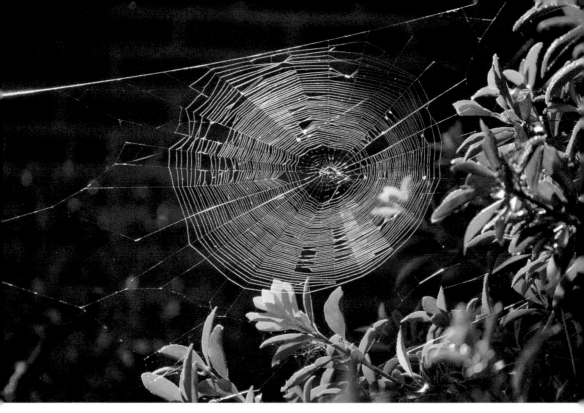

Above: Spider webs were once used to heal wounds. (Soo Wellfair)

Below: A lone magpie. (Boys In Bristol Photography)

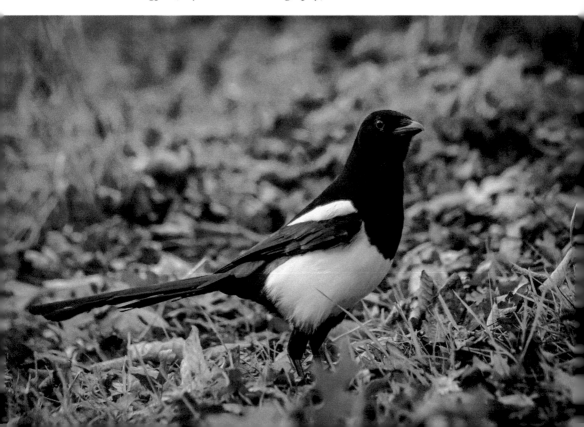

Passage Graves, Menhirs and Interesting Rocks

Guernsey is an island made of nine different types of rock, largely gneiss but also granite. With parts of the island believed to date back some 6.5 million years, it is no wonder that the very rock that forms Guernsey also features heavily in local folklore and heritage.

Neolithic Passage Graves

It is believed that the first settlers in Guernsey were Neolithic farmers. One of the legacies left by the Neolithic community are a number of stone passage graves. Although often referred to as dolmens, most are actually too large to fall into that category. The oldest on the island, La Varde, is believed to date somewhere between 4000 and 2500 BC. Le Déhus is one of the best preserved and most impressive of the Neolithic passage graves on the island. During the excavations

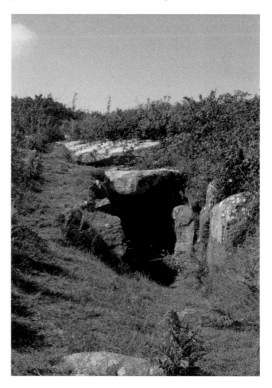

La Varde passage grave.
(Soo Wellfair)

made by Frederick Lukis in the 1830s, Le Déhus revealed some extremely interesting finds, including two human skeletons, seemingly sitting back to back. This remains something of an archaeological mystery. Le Déhus is also the home to The Guardian of the Tomb or Le Gardien du Tombeau. It's a Neolithic carving of a man, a bow and arrow and possibly symbols depicting animals around him.

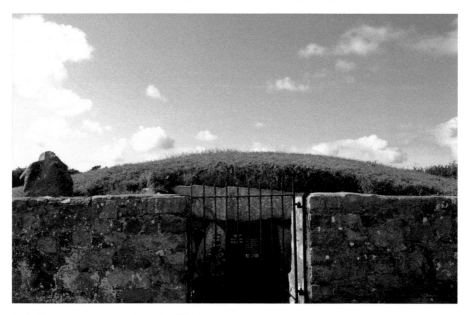

Le Déhus passage grave. (Soo Wellfair)

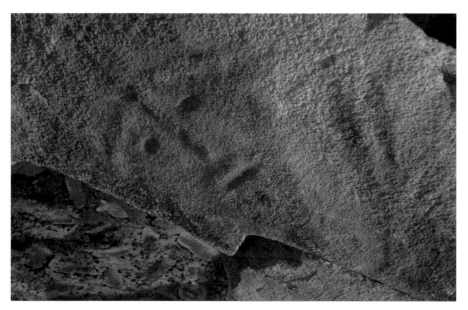

The Guardian of the Tomb. (Soo Wellfair)

The Legend of La Rocque Qui Sonne

Now situated in the grounds of a local primary school, La Rocque Qui Sonne is one of Guernsey's most interesting passage graves with an amazing bad luck story attached to it. Towards the end of the eighteenth century, it was a much larger structure than what is left today and sat within private grounds, which were owned by a Mr Hocart. The stone tomb already had a reputation for having supernatural properties so when Mr Hocart made plans to desecrate the passage grave to build a new house for himself, his neighbours warned him that it would bring him terrible luck. Mr Hocart did not listen to their premonitions and work went ahead as planned. The name La Rocque Qui Sonne actually means The Ringing Rock as legend has it, every time the stonemasons struck the passage grave when destroying it, a loud ringing sound could be heard from miles around. The warnings of bad luck that Mr Hocart had received were soon realised, when shortly after the building of the house was finished, it inexplicably caught fire and burned down. Furthermore, two shipments of rock from the passage grave, destined for sale in the UK, were mysteriously lost at sea. At this point, Mr Hocart started to wonder if there was indeed some truth in the superstitions and decided to relocate to Alderney for safety. After some time, he decided to return to Guernsey, feeling that enough time had passed and that any curse upon him would now surely have expired. However, tragedy struck on the voyage back home and some accounts claim Mr Hocart's boat sank and he drowned and others report that he was fatally injured in an accident whilst on board. However he met his end, it is likely Mr Hocart had wished he had left La Rocque Qui Sonne well alone.

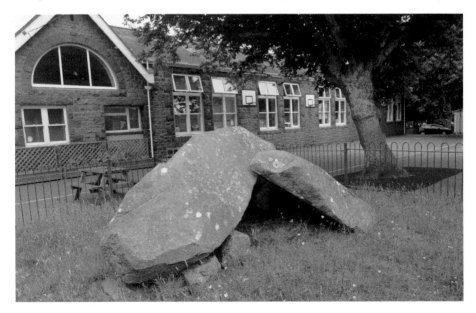

La Rocque Qui Sonne. (Soo Wellfair)

La Gran'mère du Chimquière

As well as passage graves, there are also a number of prehistoric menhirs or standing stones that can be found dotted across the island, many of which have been repurposed over the years. You will find La Gran'mère du Chimquière, an impressive stone menhir, standing outside the gates of St Martin's parish church. The Grandmother of the Cemetery is a very old lady indeed. This stone carving is thought to have originally been created around 4,000 years ago and recarved about 2,000 years ago. The most recent carvings gave her clothes, similar to the type of garments Romans wore. This is why she also has the lesser-known nickname of 'The Grandmother of Julius Caesar'. Nobody knows exactly where she came from or why she was created, although from the twentieth century onwards she has been seen as an Earth Goddess and a fertility symbol. It is traditional for brides getting married at the church to adorn the statue with flower garlands and coins for good luck. It is thought that La Gran'mère was previously located within the grounds of the churchyard and was moved outside the gates by a clergyman who disapproved of her pagan roots. This could also explain how she came to be broken in half. There is a similar statue at Castel church. It was not unheard of for pagan standing stones to be 'Christianised', meaning a cross would be carved into the rock.

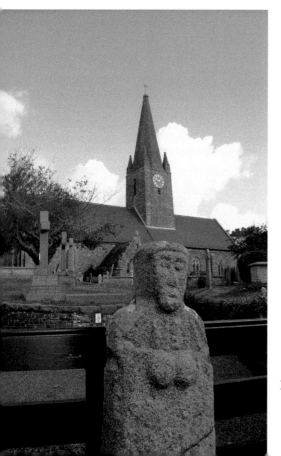

La Gran'mère du Chimquière. (Soo Wellfair)

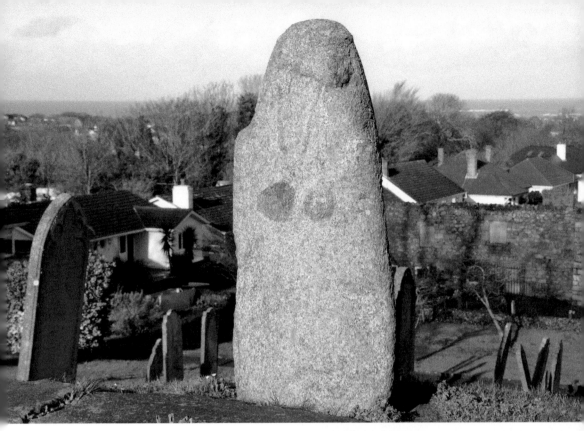

Above: Stone menhir at Castel Church.
(Soo Wellfair)

Right: A Christianised menhir, Vale Church.
(Soo Wellfair)

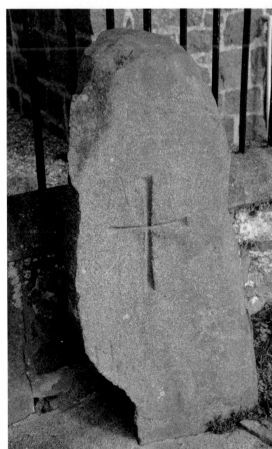

Interesting Rock Formations

With a coastline surrounded by rock formations, Guernsey has quite a collection of mimetoliths, rocks which have been carved by nature over time and now resemble people or animals. Some of the best examples are the lion, baboon and camel rocks on the west coast near Albecq. You'll find another lion rock along with a dog rock in the south of the island from Moulin Huet and at Jerbourg Point you will find the famous Pea Stacks. One of the rocks is thought to resemble a hooded monk and is known as Le Petit Bon-Homme Andriou. Legend has it, fishermen would doff their caps to Andriou for good luck whenever they were heading out to sea from a harbour in the south of the island.

Lion Rock.
(Soo Wellfair)

Baboon and Camel
Rock. (Soo Wellfair)

Notable Chapels, Churches and Graveyards from the Past and Present

From the early days of paganism, despite being such a small island, Guernsey's rich collection of churches and chapels are a good indicator of the differing denominations that have been practised throughout the centuries. Some have stood the test of time, whilst others are long-gone but remain part of Guernsey's history. There are some fascinating stories attached to many of these holy buildings and they form an important part of the island's narrative.

The Little Chapel

The Little Chapel is one of Guernsey's most famous and well-loved landmarks and sits nestled in the beautiful valley region of Les Vauxbelets in the parish of St Andrew.

Standing at just 16 feet by 9 feet, the Little Chapel may be small in size but it is mighty in visual impact. Based on the Rosary Basilica of Lourdes, every inch of the Little Chapel is adorned with a colourful array of broken china, seashells and pebbles and is an absolute feast for the eyes. This form of mosaic work is known as Picassiette, which is French for 'plate stealer', and one of the most famous examples is La Maison Picassiette in Chartres, France.

The version of the Little Chapel which stands today is actually the third incarnation of this stunning landmark. It was originally built in 1914 by Brother Deodat, a member of a French monastic order known as the Brothers of the Christian Schools, who had settled in Guernsey in 1904. They were dedicated to the education of boys and founded several colleges on the island. Deodat, inspired by the grotto at Lourdes, embarked on a building project that would span several decades. The first version of the chapel, measuring just 9 feet by 4.5 feet, was pulled down within a day as Deodat has received criticism for its small size. Soon after, Deodat completed a second, larger version but even though, at 9 feet by 6 feet, it was larger than its predecessor, it was destroyed in 1923 after the Bishop of Portsmouth was unable to fit through the doorway. And so, the building of the third and final version began. The main shell of the building, now measuring 16 feet by 9 feet, took just two years to complete. However, the decoration would continue for many years. Deodat struggled to find enough resources to complete the task until after the chapel was featured in the *Daily Mirror* in 1925. He

was soon inundated with donations of materials from around the world. Sadly, Brother Deodat was unable to finish his project as due to ill health, he returned to France just before the Second World War. Another member of the order, Brother Cephas, took over the decoration of the Little Chapel until his retirement in 1965.

The Little Chapel is a very popular attraction for both visitors and locals, and it never fails to impress. It is a beautiful part of the landscape and its form and colours can be admired from some distance. Yet it is when you get up close that you can really appreciate the intricacy and variety of all the individual pieces that make up this unique landmark. Renovation work undertaken recently has ensured that the Little Chapel can continue to be enjoyed and appreciated by future generations.

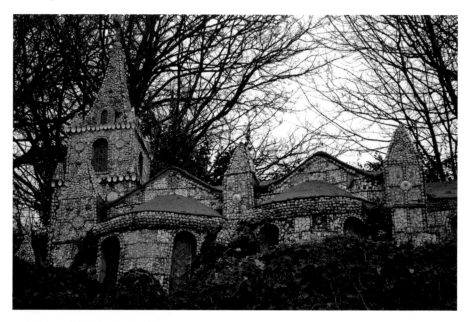

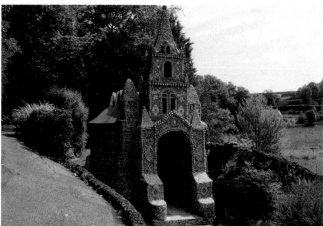

Above: The Little Chapel.
(Soo Wellfair)

Left: The Little Chapel.
(Soo Wellfair)

St Apolline's Chapel

St Apolline's is a small chapel with a very interesting story. Apollonia was a Christian deaconess in the third century. Living under Roman rule in Alexandria, she was punished for providing shelter for persecuted Christians. She was beaten so badly that all of her teeth were either broken or knocked out, and when

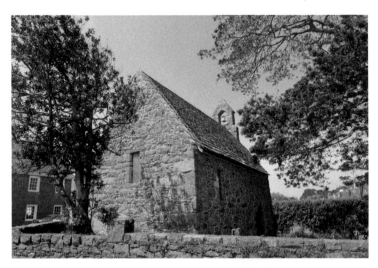

St Apolline's
Chapel.
(Soo Wellfair)

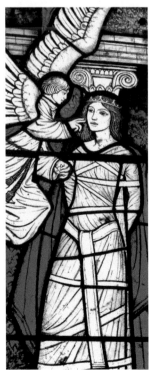

Stained-glass window depicting Sainte Apollonia, patron saint of dentists. (Soo Wellfair)

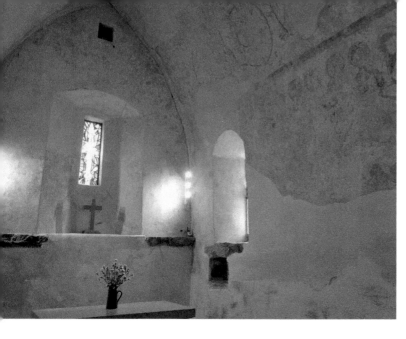

Medieval fresco of
The Last Supper.
(Soo Wellfair)

soldiers threatened to throw her onto a fire if she did not renounce her faith, she threw herself into the flames. She was made a martyr and Sainte Apollonia, patron saint of dentists. There is a window in the chapel dedicated to her, which depicts her being looked over by an angel holding a tooth.

The chapel was built in the late fourteenth century, then fell out of use after the Reformation. It was used as a stable until it was purchased in the late nineteenth century by the States and is now a protected building.

It is an attractive building, which can accommodate around sixteen worshippers at one time. One of the most unique features within the chapel are the medieval frescoes depicting the Last Supper and Jesus washing the feet of the Apostles. These historical works of art are extremely rare and part of what makes this little chapel a very special place to visit.

The Chapel of Saint Clair and a Headless Priest

There are a number of chapels that sadly no longer stand, and quite often these structures were built on pre-existing holy sites. In the north of the island, there was once a chapel dedicated to St Clair, the first bishop of Nantes. There is a rather astonishing origin story of the chapel's dedication and how this French bishop arrived in Guernsey. In the third century, Bishop Clair was well respected and known to be a good man who was loved by many. However, some of his preaching methods were considered somewhat unorthodox. His actions attracted the attention of higher ranking members within his church who did not agree with his methods and he was ordered to stop. After he refused, a small army of soldiers were sent to stop him using physical force and when they arrived Bishop Clair tried to escape them by running away. One of the soldiers managed to intercept the fleeing man, drew his sword and decapitated him as he ran. Despite now being headless, Bishop Clair continued to run from his assailant. He ran to the French coast and across to Guernsey, finally coming to a stop on a small hill,

Standing stone on St Clair Hill. (Soo Wellfair)

which became his final resting place. This was where the chapel was built and the hill named St Clair Hill. Although the chapel no longer exists, St Clair Hill remains. All that is left to indicate that it was once a religious site is a single stone; an ancient relic of this formerly hallowed place, which may have originally once been part of a larger prehistoric site.

A Little Healer Buried at St Sampson's Church

A modest little grave in the churchyard of the parish church of St Sampson marks the final resting place of an exceptional little girl named Linda Martel.

Most people in Guernsey would have heard the incredible story, and it's true that real life can often be much more amazing than fiction. Linda was born in 1956 with terrible health problems. She had hydrocephalus, spina bifida and paralysis of the legs. Things did not look hopeful for this little girl and she was not expected to live beyond a year. However, she was a fighter, and at the age of three years she started to display unusual characteristics for a child her age.

Those who met her often commented that she spoke like an adult and had the wisdom and authority of a much older person.

She also became known as a healer, and it was this gift that made Linda a household name. There are countless case studies where the sick claim to have been healed after visiting Linda in her home. Her parents received thousands of letters from people desperate for help and they would send back handkerchiefs which Linda had 'treated'. Even after Linda passed away at the age of just five years old, her parents continued to give away small pieces of Linda's clothing to those who asked for help. Sometimes items were laid on Linda's grave and it is believed Linda's healing gift could still be somehow transferred. It's an intriguing story and one which an astonishing amount of individuals backed up. Whatever happened there is no denying that this little girl touched the lives of many and was a ray of light and hope in her few short years on this earth.

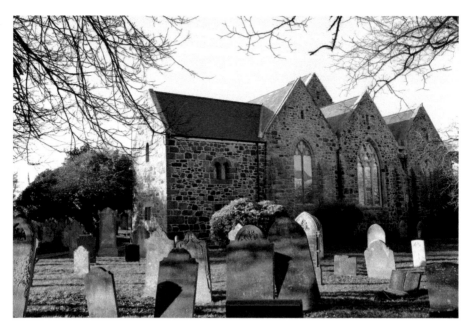

St Sampson's Church. (Soo Wellfair)

Big Sam McDonald's Final Resting Place

A public car park may seem like an unusual place for a gravestone, but maybe not so unusual if that car park was once a cemetery. The Strangers' Cemetery in St Peter was originally built in 1780, mainly as a place to bury British soldiers garrisoned in Guernsey, as well as other non-locals. Less than thirty years later, a road was built right through the cemetery, dissecting it into two parts. The same road was then widened in 1830, leading to the displacement of many of the graves and by 1882 the cemetery had ceased being used and was officially closed. Within another hundred years or so, the cemetery had been transformed into a pleasure garden, albeit with many of the gravestones still in situ, but these were gradually removed and destroyed over the years if they were in a less than satisfactory condition. In fact, every single gravestone was eventually removed, apart from one. This headstone is still there today, simply because it has been taken care of and maintained over the centuries. So who is buried there? It marks the final resting place of Sergeant Samuel McDonald, known better as Big Sam McDonald. This Scottish soldier had a long and illustrious military career but was most famously known for his size. With a height of 6 feet 10 inches and a chest measurement of 48 inches, Big Sam became well known for both his stature and his strength and he was the subject of many 'tall' tales. For example a story about his infancy claims that Big Sam's mother was unable to nurse him, and he was instead fed milk directly from his father's horse, which is why he grew to be so large! Another tale takes place when Big Sam was posted in Dublin, Ireland. A local butcher was disbelieving of the rumours he had heard about

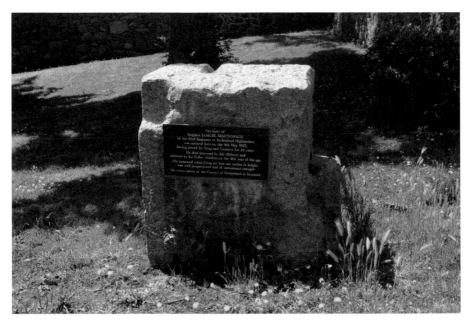

Big Sam McDonald's final resting place. (Soo Wellfair)

the soldier's immense strength so challenged him to carry a bullock the 2 miles between his shop and the army barracks. When Big Sam completed this challenge with seemingly little effort, the shocked and impressed butcher handed over the bullock for free. On another occasion, Big Sam was on duty, guarding a very large and valuable cannon. It was outside on a very cold evening and Big Sam carried the cannon inside to continue his guarding duties in the warm and stated that he could keep an eye on it just as well indoors.

Big Sam died whilst on duty defending Guernsey in 1802 and was buried in the Strangers' Cemetery and his headstone was replaced with a memorial and plaque in 1988.

The Guernsey Lady Who Lived Across Three Centuries

Another of Guernsey's long-disused graveyards is the Brothers' Cemetery, which can be found tucked away down a small lane named the Rue des Frères in St Peter Port. It is believed that it was used by Fransiscan friars and became a parish cemetery after they left the island in the sixteenth century. It was a well-used cemetery for around 200 years but was largely unused by the mid-twentieth century. The gates were locked in 1970 and the site abandoned for the best part of fifty years, with many of the graves becoming neglected and damaged. Recently, a group of volunteers have restored the site, tidying and maintaining the remaining gravestones and vaults. One of these vaults is the burial place of quite an astonishing Guernsey lady. Margaret Ann Neve, who was born in 1792 and passed away in 1903, was at the time the first recorded woman to

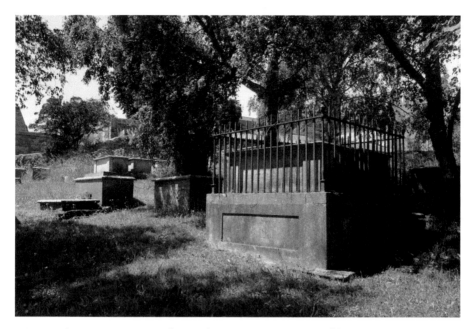

Margaret Ann Neve's grave in the Brothers' Cemetery. (Soo Wellfair)

have reached the age of 110, making her a supercentenarian. In fact, she passed away just a month short of her 111th birthday. She was also the first recorded individual whose lifetime spanned three centuries – the eighteenth, nineteenth and twentieth centuries. In her long life, Margaret Neve would have seen five monarchs on the throne. Firstly King George III, followed by King George IV, King William IV, Queen Victoria and King Edward VII. Sadly, she outlived her husband considerably, having been widowed at the age of fifty-seven after a twenty-six-year marriage. What was the reason behind Margaret Neve's amazing longevity? Firstly, good health seemed to run in the family as her own mother lived to an impressive ninety-nine years old. When Margaret was questioned about what her secret to a long life was, she revealed that she had a little sherry with lunch and a dash of whiskey with her supper and kept an active life. When Margaret Neve passed away, flags were flown at half-mast in Guernsey as a mark of respect.

The Hauntings of Vale Church

The Vale parish church has a long and interesting history. It is believed to have been built on a site originally used by pagans, and certain markings around the graveyard would certainly suggest this. This is not at all uncommon actually, as early Christian missionaries were known to actively seek out pagan sites to 'christianise'. The remains of a prehistoric passage grave also indicates that it has been an important area since at least the Neolithic period. There are also the remains of a former priory, built around AD 968 by monks from Mont

St Michel in France and the current church, largely built in the thirteenth century and greatly modified in the late nineteenth century, is dedicated to Saint Michael. Prior to 1806 Vale Church stood on a part of the island known as the Clos du Valle, which was actually a separate island from the rest of Guernsey. This meant the church was cut off by the tide and at times only accessible by boat. Several crudely constructed bridges were built to aid islanders in crossing the stretch of water known as the Braye du Valle, but these were terribly dangerous. Little more than stepping stones, they would become covered in slippery weed from the sea and it's thought that many perished by either losing their footing or misjudging the tides and being swept out by the current. The areas where these bridges once stood are believed to be haunted by the poor souls who lost their lives at sea and many a local person has claimed to have heard their unearthly wailing. The rectory of the church was once thought to be haunted by the ghost of a French rector who had stolen money from the poor box and fled the island and, shortly after, lost his life. In death, the spirit of the thief was forced to spend his eternity back at the scene of his crime. It was reported that the sound of footsteps accompanied by the unmistakable clatter of coins being dropped was regularly heard within the rectory for many years. The haunting continued until many years later, when the church buildings were being renovated. When some floorboards were removed from one of the rooms in the rectory an almighty stash of coins was unearthed. Soon after, it was decided to donate the find to charity and the ghostly rector and his coin-dropping were never heard of again.

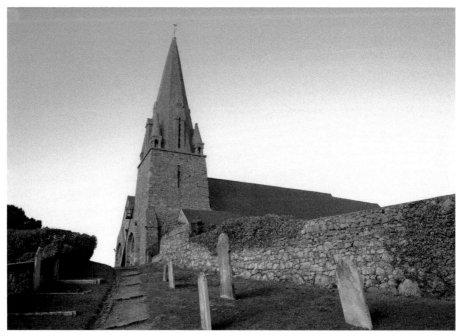

Vale parish church. (Soo Wellfair)

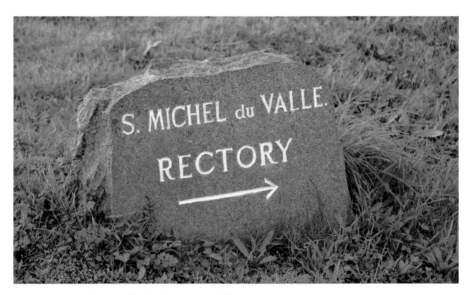

Rectory sign, Vale parish church. (Soo Wellfair)

The Tiny Cemetery at Vale Castle

Visitors to Vale Castle, situated in the north of the island, are often baffled and intrigued by a tiny cemetery within the castle's grounds. The small plot of just one or two headstones is enclosed by a low granite wall with an attractive iron gate, adorned with a cross. It's possibly the somewhat ornate appearance of the site that draws the attention of passers-by. A plaque on the wall reads 'This consecrated plot contains the mortal remains found in the old burial ground near Vale Castle Guernsey June 1928'. The 'old burial ground' refers to a former cemetery once located nearby, which once adjoined a neighbouring granite quarry. The quarry owner, looking to expand in the 1920s, had sought permission to quarry the small cemetery site. Permission was granted on the condition that the quarry owner would arrange and pay for any remains to be exhumed and reburied on consecrated ground at Vale Castle. But who were they reburying and why at Vale Castle? There are several theories behind the identities of those buried at the castle, but the most likely explanation is really quite interesting. Back in 1799 around 6,000, Russian troops were garrisoned in various spots across Guernsey, including Vale Castle. At the time the British and Russian armies were allies, having just joined forces in the Anglo-Russian raid of the Netherlands, known as the Battle of Helder or the Helder Expedition. After the opposing side, consisting of the Dutch and the French, was victorious, the British and Russian armies retreated. The Russian soldiers were sent to Guernsey to protect the island from the threat of French invasion. After a while, it soon became clear that many had contracted a terrible disease from the Dutch marshlands and a large number of them sadly died. It is these troops that are believed to be buried in the Vale Castle cemetery.

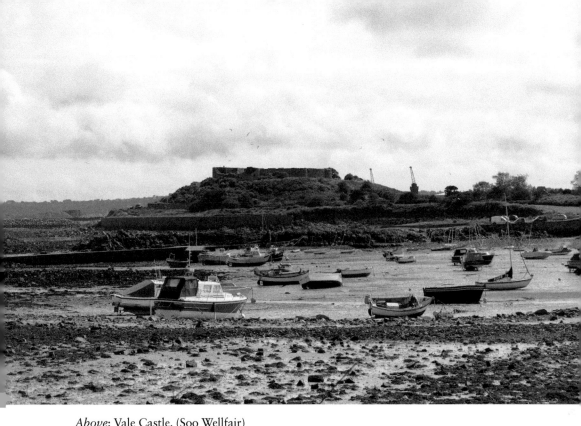

Above: Vale Castle. (Soo Wellfair)

Below: The tiny cemetery at Vale Castle. (Soo Wellfair)

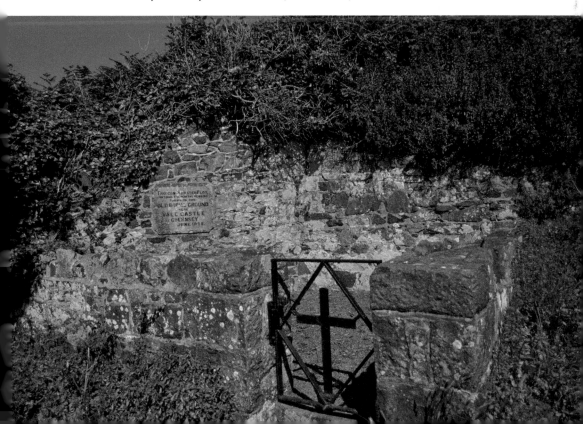

8

Law, Crime and Punishment

The Clameur de Haro

One of Guernsey's oldest institutions is the Clameur de Haro, which can be best described as an ancient and somewhat theatrical cry for help and justice! Its uses are limited and its execution is extremely specific, yet this centuries-old tradition is still called upon today. The Clameur is used by an individual who wishes to object to what they believe to be some wrongdoing taking part on their land. It only applies to land and property and a good example would be a new building encroaching onto private land. In such cases the Clameur would be raised in quite an unusual manner. Rather than raising the dispute in writing or through legal channels, the protestor would take a much more public approach. This would involve them kneeling down on the land where the dispute is taking place, with at least two witnesses spectating (one of which must be the person accused of the alleged offence). They would then raise one hand in the air and shout out the following words: 'Haro! Haro! On mé fait tort' This translates to: 'Haro! Haro! Help me, my Prince, I am being wronged.'

A local man, raising the Clameur de Haro.
(Soo Wellfair)

Following calling out the Clameur de Haro, they would then proceed to recite the Lord's Prayer in French. At this point, any work already in progress would be halted immediately. The person who raised the Clameur would then have twenty-four hours to formally put it in writing and appear before the Bailiff in court. The most famous Clameur de Haro case took place in 1087 at the funeral of William the Conqueror in Caen, Normandy. It was declared that the abbey being used for the burial was built on land stolen from the family of the individual raising the Clameur. The funeral was subsequently delayed until the landowner had received compensation.

The Clameur de Haro still exists today and is still occasionally put into practice. However, it is often used incorrectly in modern times, usually resulting in the case being thrown out of court fairly quickly. It is also something of a gamble and the individual raising the Clameur could then be taken to court themselves for unnecessarily holding up development and could find themselves being fined or sued for loss of earnings from the person or company they accused.

Omering and the World's First Underwater Arrest

A traditional and popular pastime in Guernsey is the collecting of ormers for consumption. This activity, known simply as ormering, has been part of the island's heritage for many generations. An ormer is a type of sea snail, often referred to as an abalone in other parts of the world. It is believed, however, that this particular species is native exclusively to the Channel Islands. Despite being quite ugly in appearance it is considered something of a delicacy and its unusual ear-shaped shell, made beautiful by a mother of pearl lining, is also much revered. The meat is usually either tenderised and slowly braised in a casserole or flash fried and the shells are used in jewellery making and the production of other decorative items. One thing that hasn't changed over the years are the strict rules and regulations that accompany ormering. Ormers must only be caught between 1 January and 30 April, on a new moon, full moon and the two days following. A law has recently been passed prohibiting night-time ormering. Those hunting for ormers are not permitted to do so whilst submerged or whilst using breathing apparatus or wearing a wetsuit. The only acceptable method is to wade out into the sea during what is known as an ormering tide and those collecting ormers must remain upright at all times. Only ormers over 80 mm can be taken, and should otherwise be placed carefully back where they were found, and any overturned rock should be turned back over, causing as little disturbance to the sea bed as possible. There are also rules in place regarding the sale and consumption of these rare gastropods.

In 1968 Guernsey Police made history by making the world's first underwater arrest, when a diver was discovered fishing for ormers whilst fully submerged in waters near Castle Cornet and also outside of the permitted ormering times.

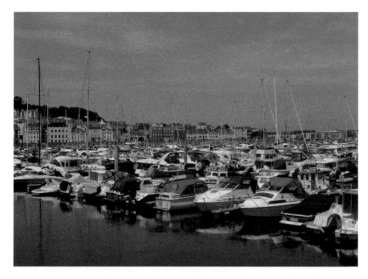

St Peter Port
Harbour.
(Soo Wellfair)

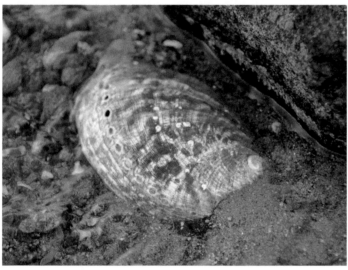

The famous
Guernsey Ormer.
(Soo Wellfair)

Guernsey's Last Public Hanging

Guernsey's last public execution took place in 1854 and is notable not just because of its historic significance. The story leading up to the execution and the way in which it was carried out makes for fascinating reading.

In 1853 a local woman called Elizabeth Saujon was found battered to death and her home set alight. The fire had not spread and had burned itself out. Had the house been engulfed it would likely have been assumed that Mrs Saujon was simply the victim of a terrible accident. However, it was quite clear, when Mrs Saujon was discovered by a neighbour, that firstly she had been brutally attacked and secondly her home had been ransacked. It was obvious that she had been murdered.

The finger was soon pointed at an Englishman called John Charles Tapner, who had been working as an engineering clerk at Fort George. A seemingly respectable family man with a steady job, Tapner was revealed to be not all he might have seemed. In fact, it was found that Tapner actually led a second life. Not an easy thing to do on an island with an area of just 24 square feet! Tapner's second family included a mistress with whom he had fathered a child. This mistress was also his sister in law. She was also lodging with Mrs Saujon. It is believed that Tapner had arranged the accommodation for his mistress and child and Mrs Saujon knew him as Mr Simmer. On the day of the murder, it would seem Mrs Saujon had let Tapner/Simmer into her home as she was familiar with him, which explains why there were no signs of a forced entry despite the mess that was later made. There are a couple of theories as to why Tapner murdered the seventy-two-year-old landlady. The first was he had visited to discuss the purchase of some furniture and an argument had ended dramatically. Another speculation was that Mrs Saujon had found out about Tapner's double life and affair, and he wished to silence her.

Whatever his motives, Tapner was found guilty by a unanimous vote, although all evidence was purely circumstantial. The trial was long for its day and attracted a lot of attention. The writer Victor Hugo, who was in Jersey at the time, followed the trial closely. He actively campaigned against Tapner being sentenced to death, not because he believed him to be innocent but because he disagreed with the death penalty. He felt that a man who committed terrible crimes only did so because of his circumstances. He started a petition and lobbied the justice system at the very highest level, but was not successful in his endeavours. A talented artist, Hugo also used the Tapner case as inspiration for several works of art.

The hanging was something of a public affair. It was held in the open air in a courtyard beside the courthouse and 200 eager ticket holders paid for the privilege to watch the execution of John Charles Tapner, who had become quite the villainous celebrity. The execution, however, did not quite go to plan. The executioner who was expected to carry out the task had taken ill, and in his absence had sent his own replacement. It would later transpire that the replacement was actually a gardener by trade and had no experience in the gallows. Understandably he was incredibly nervous and because of this, the whole exercise was an utter shambles. Firstly, the rope from which Tapner was hanged was of an insufficient length to break his neck and he was left dangling, slowly suffocating. The ropes behind his back became loose and Tapner was then able to grab the sides of the hatch through which he had just fallen and pull himself back up. The novice executioner, in a state of panic, jumped down through the hatch and proceeded to tug furiously at Tapner's legs. It took at least another twelve minutes for the deed to be done and for Tapner's life to end, and his body was left hanging for an additional hour to make sure. The hastily employed executioner never recovered from the trauma of the event and after suffering several weeks of depression was himself found dead.

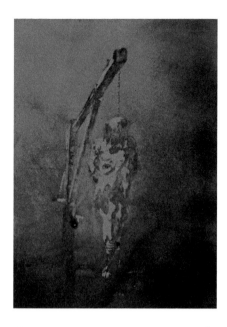

The Hanged Man by Victor Hugo.
(Paris Musees)

Guernsey's Longest Murder Trial

In 1935 the Royal Court of Guernsey held a historic trial, for two reasons. Firstly, it was the first murder trial held in Guernsey, where the defendant was a woman and secondly it was Guernsey's longest murder trial in history. Gertrude de la Mare was a twenty-seven-year-old housekeeper. Her employer, a seventy-six-year-old farmer named Alfred Brouard, had been found dead in his bed. His throat had been slashed with a serrated bread knife and beside the body they discovered what at first seemed to be a suicide note. However, not all was as it seemed. The note itself caused the police to suspect that there may have been more to the story. Not quite your typical suicide note, it merely gave instructions not to blame Ms De La Mare for his death, that it was not her fault and he had bequeathed everything he owned to her in his will. The murder weapon and the fatal wound inflicted by it also raised questions as it seemed highly improbable that such an injury could be self-inflicted. Ms De La Mare was arrested for murder and forgery and her trial was really quite a spectacle, drawing attention from the media and was documented in newspapers off-island, far and wide. Astonishingly, the prosecution actually recreated the death scene in the courtroom, using Mr Broard's actual bed, and a local policeman was drafted in to play the victim. Ms De La Mare was forced to re-enact her version of events and it would have been quite a ghoulish display. In fact, a severed dummy's head with fake blood was used to demonstrate the nature of Mr Brouard's injury to the Jurats (Guernsey's permanent jury) and one member passed out with a suspected heart attack and was taken away by ambulance. Ms De La Mare was extremely vocal during the trial and would frequently verbally attack her accusers and the Bailiff of Guernsey (acting as judge). She maintained her innocence throughout, despite all of the evidence going against her. Firstly, Mr Brouard's blood and hair was found

The Royal Court.
(Soo Wellfair)

all over her clothing, her own handwriting and poor spelling had been identified in the writing of the suicide note and she was known to have voiced her feelings of dislike towards Mr Brouard frequently. There were dozens of witnesses called to the stand, mostly agreeing that Ms De La Mare had somehow found herself financially bound to the farmer, and was to some extent under his control. Some of the witnesses were less than useful to the prosecution though. In particular, one doctor claimed Ms De La Mare suffered from epilepsy and he was quite certain she had killed Mr Brouard unintentionally during a seizure and now did not remember the event. Her mental health was questioned throughout the trial and although it was agreed that Ms De La Mare was mentally immature for her age, she was deemed sane and therefore accountable. After a thirteen-day trial, Gertrude De La Mare was found guilty of murder and promptly sentenced to execution. However, after an appeal was sent to the Home Office, the sentence was reduced to life imprisonment in a high security prison in England. The death penalty for murder was abolished in Guernsey in 1964.

The Strange Tale of Bailiff's Cross

In the parish of St Andrew, you will find an area known as Bailiff's Cross. The Bailiff's Cross is also the name of an ancient stone, which can be found in the area. It is also known as La Pierre de la Croix au Bailiff (the Bailiff's Cross Stone) or the Hangman's Stone and has an interesting story behind it. The Bailiff of the Bailiwick of Guernsey is a position still held today. Historically always a person with a law background, the Bailiff is considered to be the first citizen of Guernsey and is appointed by the British monarch. They are the head judge in the royal court and also preside over the local Government (the States of Deliberation), albeit with much less political power than centuries ago. The Bailiff of our story, usually named as Gautietier de la Salle (although his name has been questioned over the years), was thought to have been in office towards the end of the fourteenth century. He was a very powerful and wealthy man, but was notoriously greedy. His neighbour, a farmer named Mr Massey, shared access to a well on De La

Salle's land and he objected to this. He offered to purchase Mr Massey's farm on countless occasions, although Mr Massey always declined. Eventually the frustrated Bailiff decided to get rid of him by other means. He accused Massey of stealing an expensive silver cup and although Mr Massey pleaded his innocence, he was imprisoned in Castle Cornet to await trial and probably execution. His wife was told if the cup was found her husband would be freed. On the day of his trial she wandered to the Bailiff's manor house and spotted some members of his staff that she was familiar with and went to speak to them. She told them her story and in exhaustion and anguish fell back onto a nearby haystack and dislodged something. She pulled the object out and, miraculously, it was the cup which had allegedly been stolen by her husband. One of the servants, a quick-thinking man named Olivier, ran to the courthouse with Mrs Massey, and straight into the courtroom where he exclaimed 'The cup is found. It is here'. The Bailiff, not thinking, shouted at Olivier 'I told you not to touch that bale', thus instantly incriminating himself. It is believed that De La Salle was either executed at Bailiff's Cross or stopped in the area on his way to execution, where he made the sign of the cross as he was given the holy sacrament. Soon after, the stone that now stands there had a cross carved into it to mark the event. There are some questions over whether the area we now refer to as Bailiff's Cross and the current position of the stone is where the execution took place as records suggest the gallows were a bit further away, so it's possibly that the stone was moved at some point in history or, as suggested earlier, it was a part of the execution route, but not necessarily the final destination. Either way, it is a fun piece of history to locate as it's one of Guernsey's lesser-known landmarks. Some records suggest that this story is linked to another story involving the murders which famously took place on the island of Lihou, and De La Salle's execution came about from a completely different chain of events. It is not at all unusual for old local stories to become entwined like this.

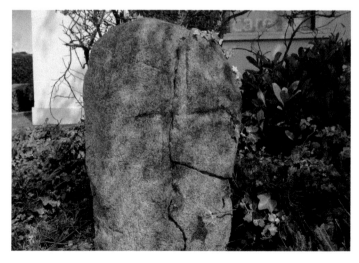

Stone marking
the Bailiff's Cross.
(Soo Wellfair)

The Infamous Lihou Murders

The beautiful, idyllic tidal island of Lihou, which can be found just off Guernsey's west coast, is the setting of a grisly murder in the early fourteenth century, which led to the deaths of four men. It is quite possibly one of Guernsey's most complicated stories, mostly due to the sheer number of individuals involved in it. If you visit Lihou today, you will find the remains of a twelfth-century Benedictine monastery. In 1304 a monk named Brother John de L'Espin was brutally murdered by a servant of the priory, Mr Thomas Le Rover. When the murder was discovered by the prior, help was sent for, and Guernsey's Bailiff soon arrived with a group of men to apprehend Le Rover. However, not all went to plan and when Le Rover resisted arrest, a fight broke out and a former Bailiff, Ranulph de Gautier, killed Thomas Le Rover. In a panic, De Gautier fled the scene and took refuge in St Sampson's Church where he was protected from prosecution. Eventually, De Gautier somehow made it off Guernsey and headed to England, where he pleaded for a pardon from the King. The pardon was granted and he returned to Guernsey, believing himself to be immune from any prosecution. When he arrived back on the island he soon realised that he had become quite an unpopular man and was soon imprisoned in Castle Cornet, where he was repeatedly tortured and tormented for the part he played in the death of Le Rover, and for his actions afterwards. De Gautier was eventually killed whilst being unlawfully tortured by his captors and three men were put on trial for his murder. This trio included Mr Gautier de la Salle, who was the only one of the three to be executed. This means the original murder on Lihou led to another three deaths, making it quite an unsavoury story indeed.

Lihou. (Soo Wellfair)

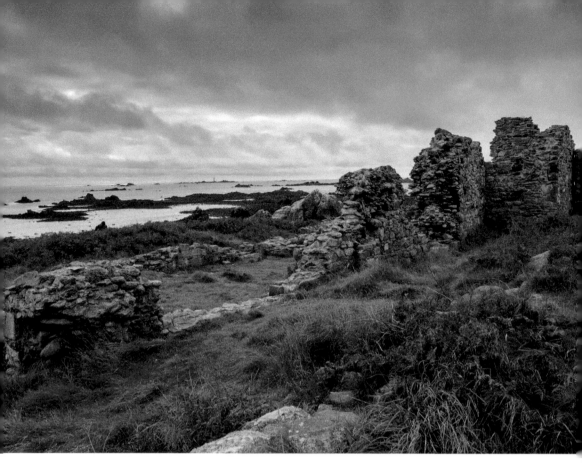

The ruined priory on Lihou. (Soo Wellfair)

Some of Guernsey's Quirkier Laws from Days Gone By

Guernsey has introduced some really quite amusing and unusual laws over the centuries, some of which are still used today. Most, however, serve to be an interesting insight in island life and are an entertaining reminder of days gone by. Some of the more noteworthy examples of odd Guernsey laws of the past include the following:

A donkey may not be ridden along a one-way road.

A man could be fined if found knitting outside, between dawn and dusk.

It was perfectly legal to shoot a man approaching Havelet Bay from the direction of France, providing it was with a bow and arrow.

If you mention a debt in the street to the person whom the money is owed to, the debt becomes null and void.

It was against the law to light a bonfire on a Monday as it was 'washing day' (although this was sometimes a Saturday, depending on who you ask).

It was illegal to ride up St Julian's Avenue on a penny farthing.

It was illegal to fly a may bug on a piece of string.

You could exchange rats tails at the St Peter Port Constables Office in return for cash.

You could not hang a man with a wooden leg.

A policeman must hold the reins of a horse if asked to by its owner.

Medieval punishments for crimes in Guernsey largely took place outside, with members of the public invited to both spectate and participate. There were various sites around St Peter Port that housed gallows for public hangings and for less severe crimes you'd find a number of pillories. The pillory was a popular medieval punishment. Similar to the stocks, which held prisoners by the feet and hands in seated position, the pillory forced them to stand upright, trapped by their neck and hands. It was extremely uncomfortable and the person incarcerated would be subjected to public ridicule and abuse as part of their punishment. Quay Street in St Peter Port was originally named La Rue du Pilori and would have been the site

La Rue du Pilori, St Peter Port. (Soo Wellfair)

of one of these Medieval structures. It is also thought that punishments would have taken place publicly by the Town Church and by the markets, where there would have been an ample supply of rotten produce to throw at the offenders.

Market Square, St Peter Port. (Soo Wellfair)

Tales from Castle Cornet

Castle Cornet was built to defend St Peter Port harbour in the early thirteenth century, after Guernsey became vulnerable to French attack after becoming loyal to the English Crown. Over the centuries, it has been the setting of some amazing stories and incidents.

The English Civil War

Between 1642 and 1651, the English Civil War saw the Government in conflict with the monarchy. Eventually the Channel Islands became involved and Guernsey was effectively at war with itself for a nine-year stretch. The reason for this was the Governor of the island was the King's official representative and resided in Castle Cornet. Whilst there were a number of Royalist supporters in Guernsey, the majority of the island was Parliamentarian so regular cannon fire took place during this period, between Castle Cornet and St Peter Port. Castle Cornet was actually the last Royalist stronghold to surrender in 1651. When the monarchy was restored in 1660, a high-ranking Parliamentarian named John Lambert was imprisoned in Castle Cornet. He had escaped execution as he had not signed the death warrant of King Charles I and was banished to Guernsey by order of Charles II instead. Considering he was found guilty of high treason when he returned for his trial in London and was at once considered a great political threat, he was treated really quite leniently. He was given certain privileges during his incarceration at Castle Cornet, including being permitted to tend a small garden, which became his own. He spent his post-war years living a simple life of gardening and contemplation, and some believe he introduced the famous Guernsey Lily to the island (although there are several different origin stories relating to this beautiful flower including the fairy invasion story already mentioned earlier). Lambert spent a comfortable life at Castle Cornet but was transferred to a prison on an island just off Plymouth

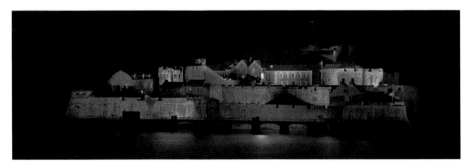

Castle Cornet. (J. M. Dean)

Lambert's Garden,
Castle Cornet.
(Soo Wellfair)

in 1667 where he remained until his death. Lambert's Garden can still be found at Castle Cornet and the pretty little outdoor space attracts many visitors.

Much damage was sustained on both sides during the English Civil War and legend has it, a building in St Peter Port is haunted by the ghost of a young British soldier billeted there, who was tragically killed after a rogue cannonball hit his lodgings.

A Great Explosion

In 1672 the keep or donjon of Castle Cornet, which was being used to store gunpowder, was struck by lightning during a terrible storm. The resulting explosion destroyed several buildings within the castle walls, including the living quarters of the current Governor, Lord Christopher Hatton. Sadly seven individuals were killed in the incident including Lord Hatton's wife, mother and a number of staff, although his children were fortunately not harmed. Lord Hatton himself was found still in his bed after being blasted across the castle grounds and onto one of the outer walls. Accounts of the incident record that he was not aware of what had happened until he was awoken by the sensation of hailstones falling on his face.

The Story of John Kemp

Castle Cornet was once Guernsey's main prison. Prisoners would have only been held there for a short period of time whilst awaiting trial, and would not have returned afterwards as most would have been either released, banished or executed. In the eighteenth century, an individual called John Kemp was being held at the castle, awaiting his trial after being accused of murdering a woman. One morning Kemp was found dead in his cell after ending his own life. The story does not end there though. In fact, Kemp's trial still went ahead and he was accused of not just one murder but two. The original murder of the woman, but also the additional murder of himself! Despite the fact that he was already dead by his own hand, Kemp was still publicly punished. His body was dragged around town and eventually hanged on a rock, now known as 'Kemp Rock'.

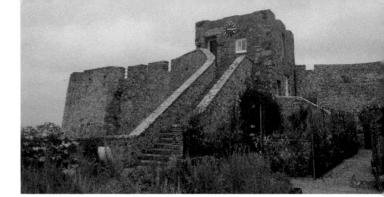

The old prison, Castle Cornet. (Soo Wellfair)

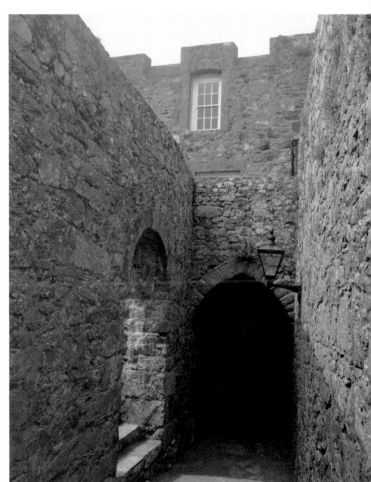

Prisoners Walk below the old prison, Castle Cornet. (Soo Wellfair

Kemp Rock. (Soo Wellfair)

A Surprise Royal Visit

A royal visit is always an exciting event in Guernsey and back in 1846 islanders were treated to a right royal surprise when Queen Victoria and Prince Albert arrived in Guernsey waters, quite unexpected. The evening before their visit, the royal yacht and accompanying vessels were spotted out at sea and a Guernsey official was quickly dispatched to meet them by boat. He brought back news that the Queen planned to come ashore at 9 a.m. the following morning and spend a couple of hours on the island before heading back to her yacht. This was the first time a reigning monarch had visited Guernsey, so understandably islanders were full of anticipation for this special event. The local paper reported how every man, woman and child were up very early that morning preparing for the regal event. The local community came together to adorn St Peter Port harbour with flowers, garlands and flags and awaited eagerly in their Sunday best to meet the Queen and Prince. Although the visit was brief, with some reports saying the couple were back on the pier, ready to leave at 10:40 a.m., the impact was immense. The visit inspired the renaming of several roads and harbour piers in honour of Guernsey's illustrious guests. A large stone engraved with the details of the visit was put in place at the top of the slipway where Victoria and Albert landed (now named Albert Pier). In 1848, an impressive tower made of Guernsey pink granite was built to celebrate the 1846 visit and named Victoria Tower. It is a very popular landmark in St Peter Port and visitors who climb the ninety-nine steps to the top of the tower are rewarded with magnificent views over Guernsey's beautiful

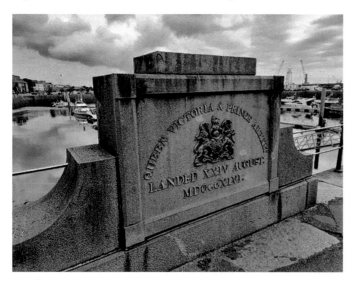

The Queen Victoria Landing Stone. (Soo Wellfair)

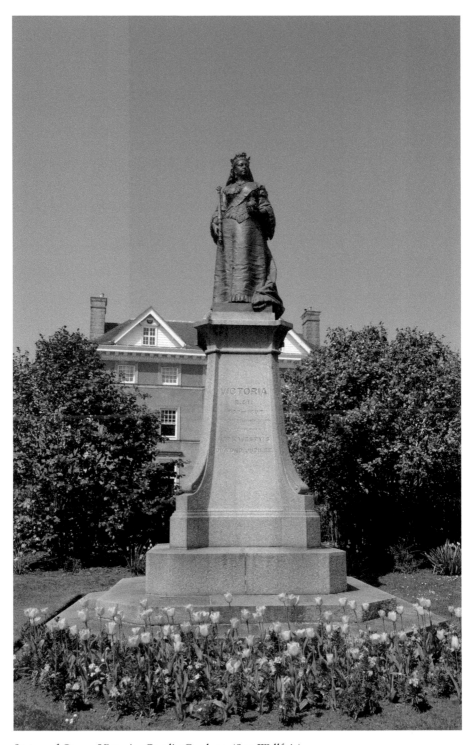

Statue of Queen Victoria, Candie Gardens. (Soo Wellfair)

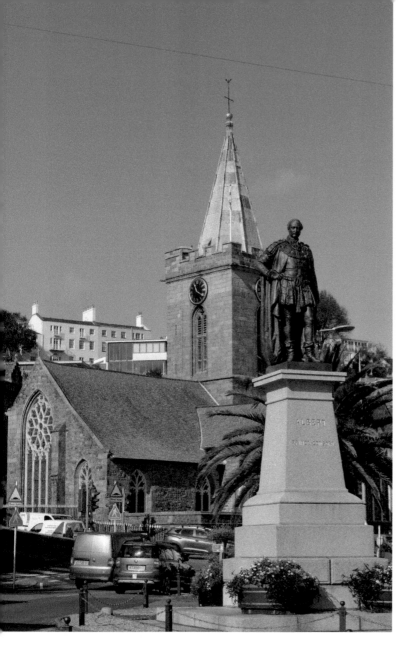

Statue of Prince Albert, St Peter Port. (Soo Wellfair)

harbour town. Queen Victoria actually returned on her own in 1851 to visit the tower. In 1863 a statue of Prince Albert was unveiled at the town end of Albert Pier and a statue of Queen Victoria in the grounds of Candie Gardens in 1900. The Victorian era was one of the most significant time periods in Guernsey's history in terms of the expansion of the town and the Victorian influences are still very much evident today. Good examples would be the bathing pools and promenade, the emplacement to Castle Cornet, the Victorian sweet shop and parlour and Candie Gardens, as well as many other wonderful reminders of this era.

Guernsey Shipwrecks

Guernsey has been an important port throughout history, particularly as part of the English Channel shipping lane. Because of the high number of ships passing through Guernsey waters and a combination of Guernsey's vast tidal ranges, fast sea currents and extensive rocky outcrops, many shipwrecks have been documented over the centuries with possibly a large number that were never identified. There is a dedicated Shipwreck Museum on the west coast of Guernsey, where the majority of wrecks would have taken place, due to a large number of reefs and rocks surrounding the coastline.

The *Asterix*

It was always something of a question mark as to whether or not the Romans had visited Guernsey. That was until the remains of a sunken Roman ship were discovered in St Peter Port harbour by a diver on Christmas Day in 1982. Ordinarily, diving is not permitted in the harbour, with the one exception being Christmas Day as there is no harbour traffic, so this was quite a fortunate find indeed. It took several years to raise the wreckage but it was soon revealed to be a Roman vessel, dating to AD 280. It was restored by the Mary Rose Trust and returned to Guernsey in 2014 and named The *Asterix*.

The *President Garcia*

In the summer of 1967, residents in the area of Saint's Bay had quite a surprise, when a cargo ship, just shy of 8,000 tons in weight, crashed in the tiny south coast harbour at twelve knots. The *President Garcia* was carrying a large consignment of Copra coconut husks (used to make oil) from the Philippines to the Netherlands. With the captain off duty and the ship on autopilot, albeit with a small crew overseeing the route, the ship had gone off course. The crew had misinterpreted several marine beacons and plotted a course which saw the ship ploughing into the rock face of the south cliffs. Luckily, nobody was hurt but the Ccptain was extremely embarrassed and the *President Garci*a was badly damaged by the rocks. The ship remained resting on the tiny harbour slipway for over a week, and during that time it became quite an attraction to curious locals, with islanders flocking to visit the wreck. What nobody had realised at the time was the *President Garcia* had brought with her a large number of stowaways in the form of millions of tiny beetles. Copra beetles are bright blue insects which live off the coconut husks, and after the ship crashed into Saint's Bay, they were released! The area was infested with these little bugs, which had not just a taste for coconut husks, but for the locals too.

They had something of an irritating bite, and terrorised residents of the parish of St Martin for a few days before quickly disappearing (possibly helped by the local gull population).

The *Prosperity*

The MV *Prosperity* was on her final voyage as a cargo ship, carrying a load of timber, when she ran into engine trouble just off Guernsey's west coast on a stormy night in January 1974. Unable to fight against the rough seas, the ship was dragged towards rocks and wrecked. With the ship damaged and taking on water, the captain ordered the crew of eighteen to abandon ship. Sadly their small lifeboat was no match for the rough waters and this, coupled with the freezing water conditions and inadequate life jackets, meant the entire crew sadly lost their lives. Some believe that had they stayed onboard the ship, their lives may have been spared as the *Prosperity* never fully sank that fateful night. Huge amounts of timber was washed up onto Guernsey's shores as a very physical reminder of the tragedy. The wreck of the MV *Prosperity* is visible during a very low tide and the reef can be visited by experienced kayakers. There is a large monument situated on the L'Eree headland which honours the lives of those lost when the MV *Prosperity* was shipwrecked.

The *Torrey Canyon*

In 1967 a supertanker named the SS *Torrey Canyon* hit rocks off the south-west of England, spilling up to 36 million gallons of crude oil. The effects of the spill were catastrophic, affecting around 120 miles of Cornish coastline and reaching as far as the coasts of Spain, France and the coast of Guernsey. It's estimated that around 15,000 sea birds were killed by the initial slick. The oil that spilled onto

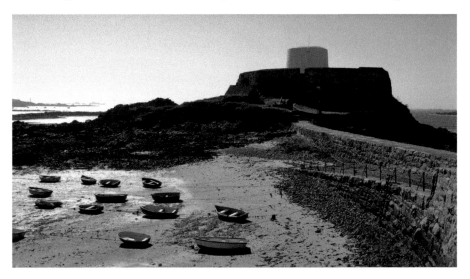

The Shipwreck Museum at Fort Grey. (Soo Wellfair)

Guernsey's shoreline was hastily cleared and dumped into a water-filled quarry in the north of the island. Although it quickly solved the problem of removing the mess and threat for the sea and beaches, it caused years and years of issues with local wildlife and the natural environment. The quarry was a very known and well used water source for local birds and they continued to dive into the water, which had now been heavily contaminated with crude oil. Over the years, various methods were used to try to get rid of the oil with very little success. In 2010 they introduced micro-organisms which effectively ate away at the oil and within a year two thirds had been removed. The floating oil was removed manually a couple of years later, using booms and buckets. All that remains is a small amount of sediment at the very bottom of the quarry, which occasionally bubbles up to the surface, where it is collected by absorbent booms, which float around and are regularly replaced.

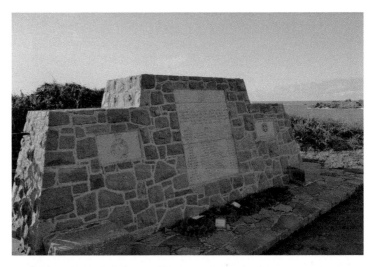

The Prosperity Monument. (Soo Wellfair)

The Torrey Canyon Quarry. (Soo Wellfair)

Guernsey's Most Famous Duel

Back when Guernsey had a regular garrison from various regiments of the British Army it wasn't unusual for members of the local population to get into quarrels with the visiting soldiers. It was also quite common for men to fight with members of their own regiment, and duelling was sometimes seen as the best way to settle these disputes. The only problem was duelling was actually forbidden in Guernsey so a number of these duels actually took place in Jersey, where no such ruling applied. There are, however, several reports of duels taking place in Guernsey and the most famous of these took place in 1795 between Major William Byng and James Taylor, both members of the 92nd Regiment of

Cambridge Park. (Soo Wellfair)

Foot. Byng and Taylor had actually been quite good friends before they had a falling out over etiquette. One account of the incident claimed that Major Byng had challenged the regiment's surgeon, James Tayor, to a duel after he was slow in standing when the national anthem was played. Taylor had argued that he did not recognise the arrangement of the song, chosen by the military band, and had meant no disrespect. Other versions of the story state that it was in fact Taylor that challenged Major Byng for the same reason. Either way, the duel was arranged to take place at Cambridge Park in St Peter Port the following morning. It was a speedy affair with Taylor fatally wounding Byng with a single shot to the head. The encounter has often been referred to as the last duel in Guernsey, although subsequent newspaper references would dispute this claim. It is undoubtedly one of Guernsey's best-known duels and there is a memorial stone marking the point at which the legendary confrontation took place. There was once an elm tree beside the stone which had the names of the two men engraved upon it, but it has long since gone.

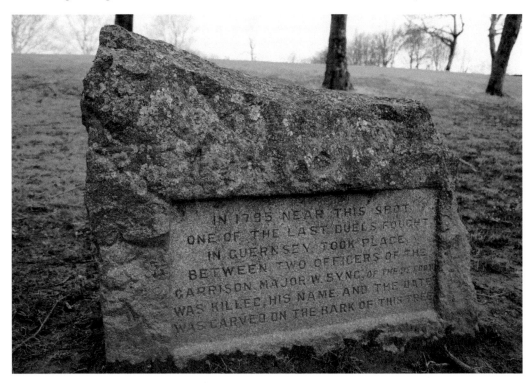

The site of Guernsey's most famous duel. (Soo Wellfair)

The Guernsey Hermit

During the Second World War when Guernsey was occupied, literally hundreds of bunkers, gun placements and tunnels were built by the occupying forces. Over the years, many of these fortifications have been repurposed in various ways and one bunker in particular, was to become the home of a local man. During the Occupation, a local man named Steve Piquet was sent off island after getting into trouble with the authorities after he was caught stealing from military stores. On his return he found himself without a home and unable to work due to a back injury. Mr Picquet was a well-known and popular local resident, particularly within the boxing community. When he returned to Guernsey after the war ended, his friends and family rallied together to help Mr Picquet rebuild his life. A disused bunker near Portelet harbour was cleared out and transformed into a home for Mr Picquet. Mr Picquet went on to become something of a recluse, becoming known locally as the Guernsey Hermit. He named his bunker dwelling 'Onmeown' and rarely allowed visitors to visit. On one occasion when he did allow a friend to enter 'Onmeown', Mr Picquet was reported to have said 'I have found a little heaven'. Despite being dubbed a loner and having very little human contact during his bunker years, Mr Picquet did not actually live alone. In fact, the famous Guernsey Hermit shared his home with a dog and no less than thirty goats! This added to Mr Picquet's growing reputation of being something of a local eccentric and he became more and more well known for this over the years. Mr Piquet is referred to multiple times in the 1981 novel *The Book of Ebenezer Le Page* by G. B. Edwards. The titular character says this of Mr Picquet: 'he looked like Robinson Crusoe. I knew he was living with four or five dogs in a German bunker he called Onmeown … he didn't seem to want me to leave him, for, though he lived on his own in the last place to live on in Guernsey and was called "the hermit" by the visitors, he was hungry for company…' Steve Piquet was also featured in a TV documentary presented by Alan Whicker and remained living in his bunker until he died at age seventy-four in 1963. The bunker is now abandoned but is still known locally as Steve Picquet's famous 'Onmeown'.

The now disused 'Onmeown' bunker. (Soo Wellfair)

'Onmeown', near Portelet. (Soo Wellfair)

The Underwater Village

In the parish of St Saviour you will find Guernsey's largest water reservoir. It holds around 240,000 gallons of water and has an impressive dam wall, which stands at 900 feet long and 118 feet high. It is a popular place for visitors as it doubles up as a beautifully peaceful nature reserve, with a stunning woodland trail which allows walkers to circumnavigate the reservoir. When water levels are high, the reservoir resembles a stunning, tree-lined natural lake and you could easily be fooled into thinking it had been there hundreds of years, rather than since the 1930s. However, a walk around the area when water levels are extremely low, you will catch a glimpse of the reservoir's beginnings. Back in 1936, it was decided that Guernsey would construct a dam and reservoir. After considering various sites, a small valley in the parish of St Saviour was chosen and £200,000 was set aside to pay for impounding the land. It was not quite as simple as it may sound as within that valley lay a number of farms and dwellings, making up what could be considered a small village and farming community. Although most of the land acquired was made up of fields and farmland, there were a number of buildings being used, including around six houses. These dwellings housed some thirty tenants, who were forced to move out with just thirty days' notice. What may come as surprising is the fact that many, if not all, of the buildings

St Saviour's Reservoir. (Soo Wellfair)

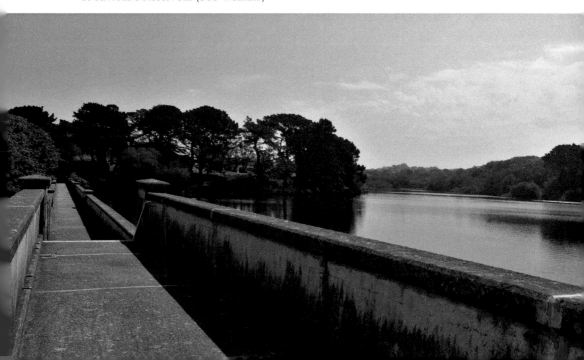

were not actually demolished prior to the construction of the reservoir, and the entire valley was simply flooded. At certain times of the year when water levels drop much lower than usual, the reservoir bed reveals the ghostly reminder of its past, when the ruins of some of the buildings become once again visible. Nestled amongst foliage and largely reclaimed by nature, some of the ruined buildings are also located around the edge of the nature walk, but it is the submerged dwellings which, when revealed, add an eeriness to the area.

Ruined farm buildings at St Saviour's Reservoir. (Soo Wellfair)

Tales from Herm

Just a short ferry ride from Guernsey, the tiny island of Herm has a fascinating history, as well as being one of the most beautiful parts of the Bailiwick of Guernsey.

Prussian Royalty, Herm Castle and a Herd of Wallabies

Herm has had a wide variety of tenants over the centuries and for twenty-six years the island was the home of several members of the Blücher dynasty, a family of Prussian aristocrats who discovered Herm in 1889. Gebhard Lebrecht, the third Prince Blücher of Wahlstatt, was to become one of Herm's longest-standing tenants and was responsible for making many changes to the island. Prince Blücher fell in love with island life and because of his wealthy background he was able to invest a lot of money into improving his new home. Although the Blüchers allowed visitors to Herm, access was quite strictly restricted with visits allowed just once a week with a charge to visit Shell Beach. The rest of the time, Herm was used as a playground for the aristocratic friends and family of Prince Blücher. Herm essentially became a private, luxury hunting reserve with a variety of game animals introduced to the wild. This included a herd of thirty wallabies,

Prince Blücher's 'Castle', Herm. (Soo Wellfair)

Wallabies were introduced to Herm by the Blücher family. (Luis La)

which would have seemed quite an exotic and somewhat eccentric notion. Unfortunately you will no longer find wallabies in Herm as the herd was wiped out by some members of Blücher's staff, who went on something of a shooting spree one day. Prince Blücher also transformed the main manor house into his very own castle by having a crenellated rooftop added to the building. As well as building extravagant follies and introducing strange and exotic species to the island, Blücher also improved the infrastructure, maintained the island more efficiently and more enthusiastically than previous tenants and introduced a wide variety of plant life which thrived in the warm climate. Sadly the Blücher family were forced to leave Herm under bad terms when the First World War broke out. Prince Blücher's third wife, Princess Wanda Blücher, was enraged by the terms of their eviction and put a curse on the island and all future residents. A future tenant, the famous writer Compton McKenzie, firmly believed in Princess Wanda's curse and felt it explained a number of strange and mysterious events that occurred during his tenure.

The Mysterious Monks of Herm

Many people over the years have reported to have seen ghostly apparitions of monks. Over the centuries there have been various monastic settlements on the island so it's not surprising that ghostly brothers are often witnessed. It is believed that the first group of monks were Christian missionaries, possibly originally from Wales, in the sixth century. However, the group of monks that are most associated with Herm are the Norman Friars that would have settled on the island in the eleventh century. It was this second group that really made Herm their home. They constructed buildings, farmed the land, kept animals and bees, built boats and learnt to fish and gave religious instruction. They built St Tugal's Chapel, a small but beautiful place of worship which is still used today and is one of the sites where hooded apparitions have been reported. In fact, the ghost of a monk was once spotted regularly, kneeling by the altar of the chapel or outside the entrance. Several years ago when some maintenance work was being carried

out, workmen found a rather odd discovery. They found the skeleton of a man, buried standing upright in the doorway, facing the chapel. It is believed that it could have been the remains of a disgraced monk, forced to face his chapel but unable to enter. There is a chance that he was a victim of a gruesome act known as immurement. The word immurement comes from the Latin term *im muras*, meaning simply 'in the wall'. It was a form of punishment, usually reserved for disgraced monks and nuns, who would be imprisoned or bricked into enclosed spaces and left to suffocate or starve to death. Although mainly used as a form of punishment, it was also sometimes used as a way to bless the foundations of a new building and to ward off evil spirits.

Strangely, since the skeleton at St Tugal's Chapel was discovered, the ghostly monk was never seen again. However, there are still sightings of ghostly monks around other areas of the island, especially around an area known as the Valley Panto. The Valley Panto is also known for an unusual environmental phenomenon, which takes place there every evening at around 11 p.m. The main road leading from the harbour to the Manor Village is called simply The Drive, and it passes right by the Valley Panto, and many have felt the temperature suddenly drop as they approach this area then rise again as they pass it. The Drive is also said to be haunted by a rather helpful monk who occasionally gives weary walkers a gentle push up the steep hill.

St Tugal's Chapel, Herm. (Soo Wellfair)

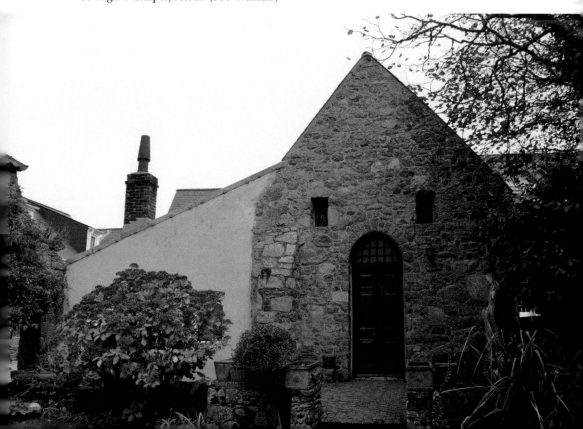

Above: The Valley Panto, Herm. (Soo Wellfair)

Below: The Drive, Herm. (Soo Wellfair)

The Legend of Barbara's Leap

Herm is well known for its varied landscape, and one of the most popular parts of the island with walkers in particular is the coastal path, which snakes its way around the shore. At points, the path is elevated with spectacular views across the sea and to other islands beyond, as well as giving walkers amazing views of small bays and coves, often from rocky peninsulas. Many of these headlands are marked on maps and named and if you were to follow Herm's southern cliff path you will find Barbara's Leap. The story behind it is as dramatic as the landscape! Legend has it, Barbara was a young girl who resided on Herm with her family. One summer she fell in love with a young man who had moved to the island as a seasonal worker. Unfortunately for Barbara, this holiday romance was destined to be just that, and she was sadly heartbroken when her first love broke off their courtship and left the island. Barbara was devastated and unable to face the world without her beloved, she threw herself off one of the highest cliff points onto the rocks below. The fall itself did not end Barbara's life, although she was terribly injured and unable to move and her cries for help were unheard. As Barbara lay broken and bereft, the tide eventually made its way in and Barbara's tragic life came to an end when she was drowned. It is believed that Barbara's Leap is haunted by the tormented spirit of a troubled, heartbroken young girl and some people say the terribly howling sound of the wind on the sea in the area mimics the cries of poor Barbara.

Barbara's Leap, Herm. (Soo Wellfair)

Herm's Mysterious Cemetery

One of the Bailiwick's smallest cemeteries can be found just off Herm Common, overlooking the sea. It is a pretty little plot with just two small headstones. Although there are a few stories circulating about who is buried there, the most popular theory is that the graves belong to a mother and her child. In 1832 when much of the world was in the grip of a terrible cholera epidemic, a vessel travelling to Guernsey was struck down with the disease. A young woman and her small child, who were passengers on the ship, sadly died of cholera whilst at sea, and when the crew docked in Guernsey and informed officials of the death, they were turned away. The bodies were rather hastily buried on Herm and the gravestones were provided by local quarrymen who were based on the island at that time. A ghostly monk is said to watch over the cemetery.

The Herm Cemetery. (Soo Wellfair)

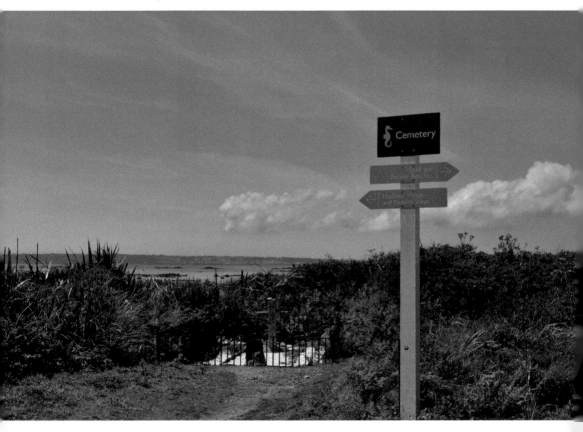

Tales from Sark

The Patron Saint of Sark

St Magloire is the patron saint of Sark, and was believed to have introduced Christianity to the small island in AD 565 and at that time set up a retreat, establishing a fairly large monastic community. There are several stories of miracles performed on the island and accounts of some quite astounding events surrounding Magloire and his loyal followers.

One such story involves a group of French children, who had been sent to Sark to receive education. One day, some of the children were playing in an old, wrecked fishing boat, when it was suddenly dragged out to sea. Sark's currents are strong and the waters rough and unpredictable and it wasn't long

A cave in Sark. (Sark Tourism)

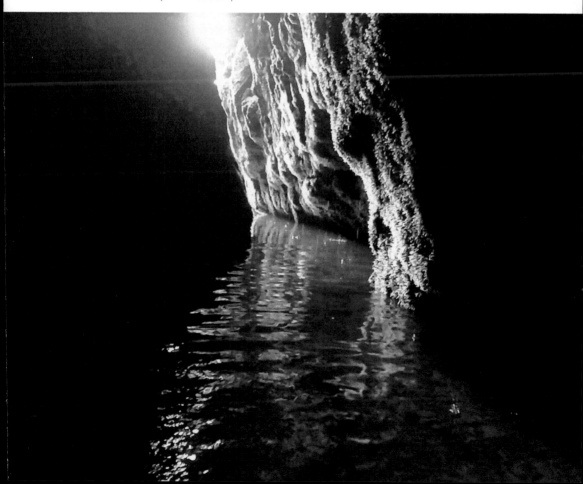

before the children found themselves getting pulled further and further into the tempestuous waters. The terrified youngsters were in fear of their lives and could not believe their eyes when, all of a sudden, they spotted a glowing figure making its way across the dark waters towards them. It was St Magloire and he had come to their rescue. Without a word he guided their small boat to the safety of a nearby cave, where they would be sheltered and secure for the rest of the night. In the morning they were discovered by a fishing boat and returned unharmed to land. The students told the story of their rescue and as a way to thank St Maloire, the boat was sent back out to sea, laden with food and gifts as an offering. The boat later returned to the shore of its own accord, now empty.

There was once a beautiful shrine dedicated to St Magloire, and after his death at the age of eighty-two in AD 857, St Magloire was buried there. A couple of centuries after St Magloire's death, a group of Breton monks decided they wanted to build a new priory and felt that St Magloire's remains belonged there, in France. In quite a shocking move, the Breton monks carried out a raid on Sark and the shrine and set about taking the remains back to France. They were discovered and pursued by islanders but it would seem that St Magloire wholly approved of his extrication, as legend has it he assisted the Bretons by somehow making his coffin weightless, which enabled them to escape at speed to their waiting vessel. Their mission was successful and St Magloire was returned to his homeland. The shrine eventually fell to ruin.

The Hauntings of La Coupeé

Bridging the gap between Sark and Little Sark is a spectacular isthmus known as La Coupeé. This elevated causeway is around 100 metres long and almost as high, and crossing over is not for the faint hearted. Before 1900 when railings were put in place, it was not unheard of for islanders having to crawl across the dirt path from one side to the other, for fear of being blown over. It is of course perfectly safe these days, although some will still not make the crossing for reasons other than health and safety. It is a notorious site for ghostly encounters. A terrifying demon dog, much like those witnessed over in Guernsey, is said to prowl along La Coupeé at night, especially when the fog banks drift in, making it very difficult to see between the two Sarks and causing people to become disoriented. Another demonic creature said to haunt the area is a phantom horse with a headless rider, which gallops along the pathway at great speed towards any unlucky walkers who just happen to be in the way!

With caves, rocks and extremely rough seas either side of the isthmus, it's no wonder that there are a number of stories of maritime hauntings. One of these caves is named La Caverne des Lamentes, which translates as 'The Cave of Sorrows'. Many people have reported an awful howling noise coming from the cave and legend has it the cries come from the souls of the many sailors driven into the rocks by pirates.

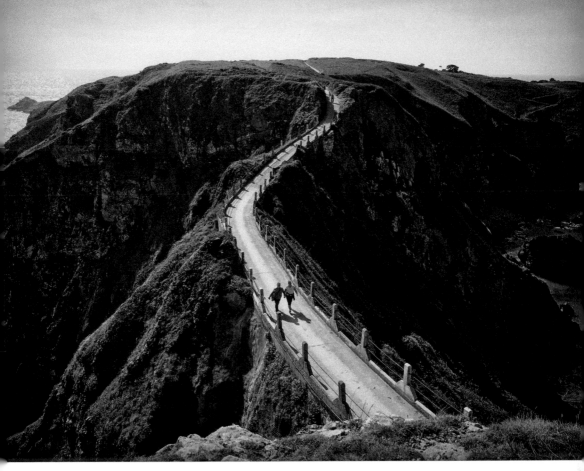

La Coupeé, Sark. (Kay Edwards)

Not Stonehenge … But Sark Henge

It takes a little effort to find it, and it is not even close in size to its Wiltshire counterpart, but Sark Henge is still worth visiting. It may be small in stature, and it was only constructed in 2015 but Sark Henge still has an interesting story behind it, which dates back hundreds of years. It was erected to celebrate an extremely pivotal point in Sark's history and marked the 450th anniversary of Queen Elizabeth I handing over the feudal rights to Sark to Jerseyman Helier de Carteret. In 1565 Sark was an uninhabited, barren island, vulnerable to pirates. Helier de Carteret was made Seigneur of Sark, with full control and rights of the island on the condition that he would bring with him forty individuals to each take over a tenement of land to restore, farm, live on and protect. With de Carteret as essentially the head of the island, his tenants would raise their families on Sark and their land would be passed down through future generations to help maintain a healthy population. Sark Henge is also a very physical reminder of Sark's feudal system as the very materials it is constructed out of were once part of an old fencing system. The stones all have a hole cut out of them. This type of stone was known as a 'henge' and would have originally been used as a sort of hinge, which formed part of a fence or gate, usually with a wooden post threaded

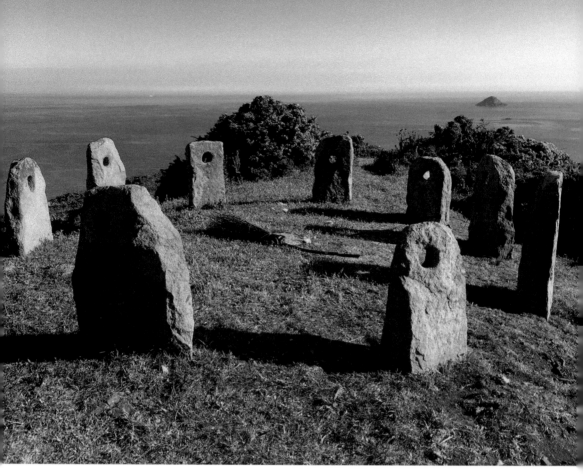

Sark Henge, Sark. (Sark Tourism)

through the hole. These stone henges and their fences were used to mark land boundaries, so the name Sark Henge refers not only to the physical similarity between it and the famous Stonehenge in England, but also to the history and origins of its core materials.

The Sark Silver Mines

Many people know that the islands that make up the Bailiwick of Guernsey were once heavily quarried for stone. What most won't realise though is that Sark was also part of an even more exciting venture; silver mining. Back in the mid-nineteenth century, after many years of speculation and rumours, permission was granted to open several mine shafts on Little Sark. It was quite an ambitious enterprise, given the modest size of the site, but clearly those involved felt there was great potential. It is believed that as many as 250 experienced Cornish miners and seventy locals made up the workforce and the island had never been so densely populated in its entire history. The owners of the mines were confident that the excavations would be extremely lucrative. However, the project did not go quite as smoothly or successfully as anticipated. Firstly, the location wasn't ideal with the mines regularly flooding with seawater

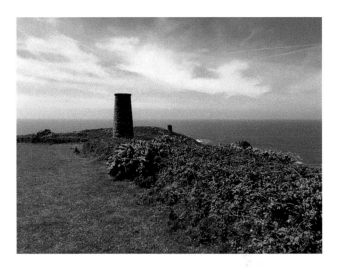

Chimney from the
old Sark mines.
(Sark Tourism)

and secondly it turned out that Sark wasn't quite as rich in valuable minerals as first hoped. The amount of usable silver and lead discovered did not meet the expectations of those who had invested a great deal of time and money into the endeavour. In fact, it is believed that a mere £4,000 worth of raw material was mined, compared to the overall cost of the operation, which stood at around £34,000. Several of the investors were ruined by the venture, including the Seigneur of Sark, who sold his title to recover some of his lost funds. All that remains now are the mine chimneys, which still stand on the common of Little Sark and act as a stark reminder of an ambitious venture that never quite made its mark.

The Dame of Sark

Dame Sibyl Hathaway, known better as the Dame of Sark, ran the island between 1927 and 1974. She had inherited her title and role from after the death of her father William Collings, who was Seigneur of the island. At this point in her life, Sibyl had already been widowed after a marriage to her first husband, Dudley Beaumont. After her father's death she moved back to Sark with her children, to take on her new role and move into the Seigneurie, the grand manor house inhabited by all Seigneurs. Sibyl's life before her tenure as Dame of Sark had been an eventful one. Always an adventurous and ambitious woman, Sibyl's strained relationship with her father whilst he was alive meant Sibyl found life on Sark, as a young woman, frustrating. She was a well educated and talented individual and her interests in the theatre and travel led her around Europe. She was well known as an actress, producer and writer and spoke several languages. She was something of a socialite in her earlier years and in the period shortly before moving back to Sark had been dubbed 'The Merry Widow'. During the First World War, Sibyl had trained as a Red Cross nurse and had also taken on duties in the War Office in London. This experience would come in use later in her life, when in 1940 Sark

was occupied during the Second World War. It is Sibyl's story during the war years that she is quite possibly best known for. At this point, Sibyl had remarried and whilst technically her second husband Robert Hathaway held the official title of Seigneur, Sibyl was still very much in charge. Sibyl encouraged all islanders to remain on Sark during the Occupation, rather than evacuate. She felt it was important for the island to pull together to protect both their land and property and the Sark community. It is believed that Sark sustained much less damage than other occupied territories because of this, and it also helped greatly that Sibyl spoke fluent German. One of the most famous stories relates to the day that the occupying forces arrived on Sark. Sibyl was ready to receive the German officers at the Seigneurie but made sure that it was done very much on her own terms. Both she and her husband Robert sat at a table at the far end of a long room and the visiting officers were made to walk right up to them to introduce themselves. Some sources say that they had even been asked to remove their boots before entering. The occupation years in Sark were tough, including the deportation of many islanders including her husband. However, Sibyl was able to maintain a level of leadership and control by establishing a relationship with those who held

The Seigneurie, Sark. (Beth Owen)

her island for five years, and they came to respect this formidable woman. At the time, islanders criticised Sibyl for what they considered to be fraternising with the enemy, but post-war, many could see that Sibyl's efforts during those years of oppression had saved Sark in many ways. Sark wasn't liberated until the day after Guernsey, although full control was handed back to the Dame and she set about using the workforce she had at hand to full use, putting the occupying troops to work, tidying up the island and making repairs. Sibyl, Dame of Sark, passed away at the age of ninety years old and was buried at St Peter's Church. She will forever be an important and fascinating part of Sark's history.

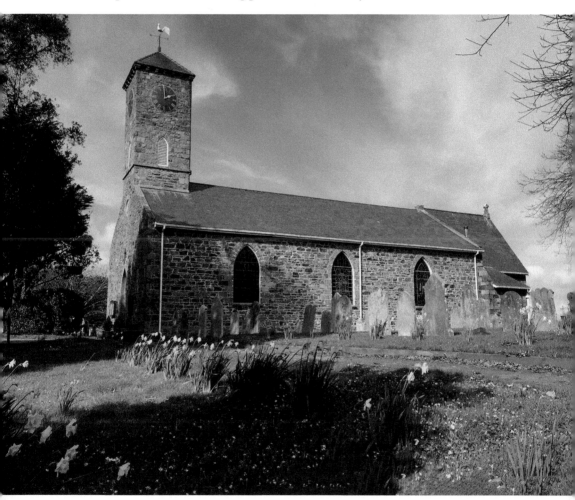

St Peter's Church, Sark. (Sark Tourism)

Tales from Alderney

Lager Sylt

During the Second World War, the entire population of Alderney was evacuated to the UK, leaving the island at the mercy of occupying forces. By the end of 1941 the island had been repopulated by close to 2,500 Germans, with around 3,000 in later years. This was double the initial population of the island. Four Operation Todt labour camps were set up in Alderney and were each named after a German island. These were Lager Helgoland, Lager Norderney, Lager Borkum and Lager Sylt. By 1943 it's believed that as many as 4,000 forced labour workers were in these camps after being sent to Alderney to construct the many fortifications that helped strengthen Hitler's Atlantic Wall. Things were to take an even more unpleasant turn in March 1943 when Lager Sylt was handed over to the SS (the Schutzstaffel or political soldiers of the Nazi Party). It is also thought that Lager Norderney was also converted into a concentration camp. They were to become the only known Nazi concentration camps in the British

Lager Sylt, Alderney. (Soo Wellfair)

Isles and were used mainly for the detention of political and Jewish prisoners. Whilst little is known about the atrocities that occurred at Lager Sylt and the other three camps, it is believed that at least 700 lives were lost whilst these sites were in operation and around 400 of those were prisoners of Lager Sylt. All that remains of this now infamous site are the gateposts that would have once marked the main entrance to the compound, which were uncovered recently by conflict archaeologists. A plaque commemorating the lives of those imprisoned there has also now been added and moves are being made to make it a protected heritage site.

The Madonna Stone

Not far from the Val du Saou, you will find an interesting stone statue. Known as the Madonna Stone or often the Grey Lady, the stone is thought to bear the form of a woman in a hooded cloak, looking out to sea. Some people have claimed that when they have approached the stone, she has taken on a much more human form, revealing a detailed face beneath her hood. It is said that this happens very quickly and the Madonna returns from stone to living and back again, almost in the blink of an eye. There is a sad but fascinating story behind her origin. Legend has it there was once the wife of an army officer who, unhappy in her marriage, fell in love with a local fisherman. They would meet in the evenings by the cliff tops on the south of the island where they would plan to one day escape Alderney and be together. Unfortunately the fisherman was killed one night whilst out in his boat in a terrible storm, and the grief-stricken woman would stand looking out to sea every evening, thinking of her lost love. On one of these nights another great storm took place and as the woman stood in the rain crying, her pain became too much and she was turned to stone.

The Legend of Hanging Rock

Protruding at an odd angle from the cliff face just below Essex Castle is a local landmark known as Hanging Rock. But how did the rock come to be in such an unusual position? One folklore story claims it was the work of the Devil himself. A number of Guernsey residents were feeling somewhat resentful towards their neighbours over in Alderney. It was felt that the people of Alderney considered themselves to be superior and thought that all Guernsey people were jealous of their beautiful island. A small group of Guernsey folk summoned the Devil and asked him to make mischief and do something to make Alderney and its inhabitants look foolish and prove that Guernsey was the better island. One night the Devil tied a rope to Alderney and presented the other end to the people of Guernsey, stating that if they pulled hard enough, they would be able to drag Alderney into Guernsey waters and could claim supremacy over them. They pulled and they pulled, using all their might. However, it turned out that Alderney really wasn't going to move that easily, and their furious tugging merely

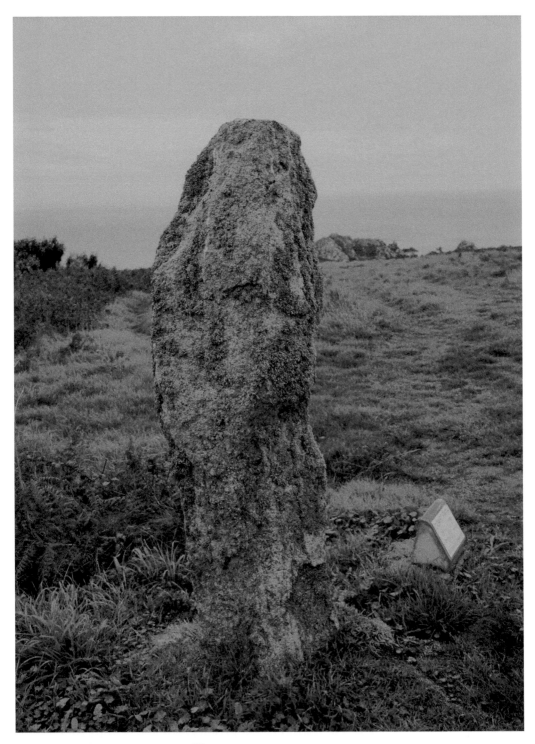

The Madonna Stone. (Soo Wellfair)

resulted in bending the rock from which the rope was tethered, thus creating the protrusion now known as the Hanging Rock. In another story, the rock was once the nose of an old woman called Mrs Robilliard. Mrs Robilliard was known locally as being something of a busy body, always poking her nose into the affairs of others. A local warlock had grown sick of this intrusion and warned her to keep her nose out of his private business or she would be sorry that she did. Nosey old Mrs Robillard took no notice of the warlock's threat and continued with her meddlesome ways. Infuriated, the warlock cast a spell on Mrs Robilliard's nose, causing it to grow enormously! Mrs Robilliard quickly sought out the help of a white witch who was unable to shrink the giant nose, but was able to remove it. The warlock took possession of Mrs Robilliard's oversized nose and displayed it on the cliffside to act as a deterrent to others. It eventually became petrified over the years and transformed into the Hanging Rock.

The area around Hanging Rock is considered to be quite haunted. Essex Castle has a resident ghost that regularly appears out of a cupboard, walks around the castle and returns to his hiding place. It is also believed that tunnels that lead from Essex Castle down to the nearby Roman fort known as The Nunnery are haunted by a young nun who was held prisoner between the fort and the tunnels.

The Hanging Rock, Alderney. (Soo Wellfair)

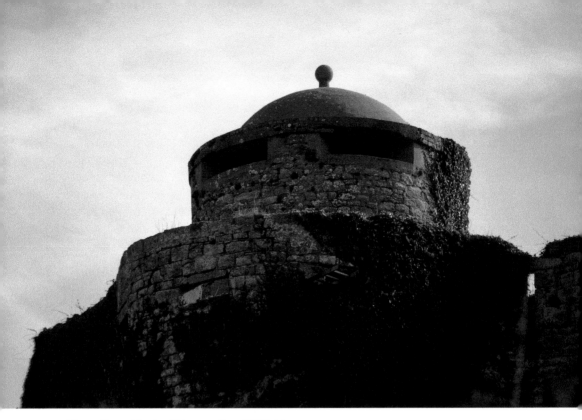

Above: Essex Castle, Alderney. (Soo Wellfair)

Below: The Nunnery, Alderney. (Soo Wellfair)

Raz Island

Raz Island is a small island just off Longis Bay. It is the home to Fort Raz and can be reached by a causeway at low tide. The area is thought to be extremely haunted. One of the most disturbing of these hauntings is the ghostly funeral procession that follows the causeway towards Essex Castle. For those who have witnessed it, it is said to be quite a spectacle with dozens of apparitions forming the group, singing loudly as they make their journey. The singing itself is quite perplexing, given that every member of the procession is in fact headless.

Some also believe that mermaids swim in the waters around Raz Island, although it is actually believed that they are not in fact mermaids, but sirens. Although they appear similar in appearance, sirens are malevolent creatures that like to lure men to the watery deaths with their enchanting voices. When crossing the causeway to the fort, soldiers would often put their fingers in their ears in fear of succumbing to the siren's spell.

The Harrods Hedgehogs

Back in the early twentieth century Harrods, the London department store, opened its very own exotic pet department. For around fifty years they sold a whole range of unusual and rare pets, until the Endangered Species Act was

Raz Island, Alderney. (Soo Wellfair)

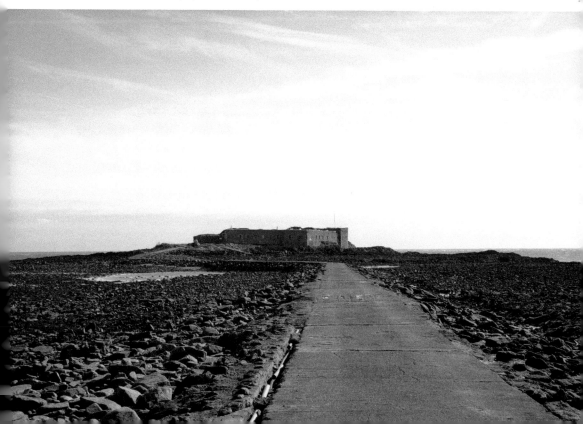

The blonde hedgehog. (Martin Batt)

introduced in the 1970s. They famously sold a lion cub to a group of friends, who named him Christian, in 1969. Christian was eventually released into a Kenya reserve after he outgrew his owners' Chelsea flat. There are even rumours of US President Ronald Regan attempting to buy an elephant. They did have a lot of success in selling smaller animals for the less ambitious pet owner and this quite possibly included blonde hedgehogs. It is believed that a pair of blonde hedgehogs, purchased from Harrods, were taken over to Alderney and either escaped or were released into the wild. Blonde hedgehogs are extremely rare, mainly because their distinctive colouring makes them an easy target for predators. However, in Alderney the species has thrived as there are few natural predators, the habitat is ideal and they have become a local treasure and protected. The blonde hedgehog has become quite an iconic symbol of Alderney wildlife and many visit the island to catch a glimpse of these extraordinary critters.

Bibliography

Printed Resources

Bellows, T., *Channel Islands Witchcraft* (Lulu Publishing, 2008)

Cooper, G., *Foul Deeds & Suspicious Deaths in Guernsey* (UK: Wharncliffe Books, 2006)

Daly and Guy., *A History of Sark's Seigneurs & La Seigneurie* (La Seigneurie Gardens Trust, 2014)

De Carteret, A. R., *The Story of Sark* (London: Peter Owen Ltd, 1956)

De Garis, M., *Dictiounnaire Anglais-Guernesiais.* (Andover: Phillimore, 1967)

De Garis, M., *Folklore of Guernsey* (Channel Islands: La Société Guernesiase, 1975)

Hathaway, S., *Dame of Sark* (London: Heinemann, 1961)

Kalamis, C., *Hidden Treasures of Herm* (Chichester: The Better Book Co., 1996)

La Trobe, G. and L., *Coasta, Caves and Bays of Sark* (Lazarus Publications, 1914)

Linwood Pitts, J., *Witchcraft and Devil Lore in the Channel Islands.* (Minnesota: Filiquarian Publishing LLC, Republished 2009 (original date unknown)

Macculoch, E., *Guernsey Folklore* (Forgotten Books, 1903)

Marshall, M., *Herm, Its Mysteries and Charm* (The Guernsey Press Company, 1958)

Martin, P., *Wrecked: Guernsey Shipwrecks* (States of Guernsey, 2019)

Picot, F. M., *Folklore and Customs of Alderney* (La Société Guernesiaise, 1929)

Remphry, M., *Sark Folklore* (Sark: Gateway Publishing, 2003)

Simons and Lihou., *Murder in the Islands* (Jersey: Redberry Press, 1987)

Wolley, F., *Guernsey Legends Broadcast on BBC Radio Guernsey* (The Guernsey Press Company, 1986)

Wood, J., *Herm Our Island Home* (Robert Hale & Co., 1972)

Online Resources

www.museums.gov.gg

www.visitguernsey.com

www.bbc.co.uk

www.britishnewpaperarchive.co.uk

www.gov.gg

www.sark.co.uk

www.visitalderney.com

www.herm.com

www.pexels.com

www.britannica.com

www.guernseypress.com

Acknowledgements

With thanks to Paris Musees, Vale Primary School, La Carriere Riding Stables and Sark Tourism.